D1513043

Routledge Performance Practitioners is a series of introductory guides to the key theatre-makers of the last century. Each volume explains the background to and the work of one of the major influences on twentieth- and twenty-first-century performance.

Tadeusz Kantor – a theoretician, director, innovator and painter famed for his very visual theatre style – was a key figure in European avant-garde theatre. He was also known for his challenging theatrical innovations, such as extending stages and the combination of mannequins with living actors. The book combines:

- a detailed study of the historical context of Kantor's work
- an exploration of Kantor's own writings on his theatrical craft
- a stylistic analysis of the key works, including *The Dead Class* and *Let the Artists Die*, and their critical reception
- an examination of the practical exercises devised by Kantor.

As a first step towards critical understanding, and as an initial exploration before going on to further, primary research, **Routledge Performance Practitioners** are unbeatable value for today's student.

Noel Witts is Visiting Professor of Performing Arts at Leeds Metropolitan University and Senior Research Fellow at the University of the Arts, London. He is co-author (with Mike Huxley) of *The Twentieth Century Performance Reader*, published by Routledge.

ROUTLEDGE PERFORMANCE PRACTITIONERS

Series editor: Franc Chamberlain, University College Cork

Routledge Performance Practitioners is an innovative series of introductory handbooks on key figures in twentieth-century performance practice. Each volume focuses on a theatre-maker whose practical and theoretical work has in some way transformed the way we understand theatre and performance. The books are carefully structured to enable the reader to gain a good grasp of the fundamental elements underpinning each practitioner's work. They will provide an inspiring springboard for future study, unpacking and explaining what can initially seem daunting.

The main sections of each book cover:

- personal biography
- explanation of key writings
- description of significant productions
- reproduction of practical exercises.

Volumes currently available in the series are:

Eugenio Barba by Jane Turner
Pina Bausch by Royd Climenhaga
Augusto Boal by Frances Babbage
Bertolt Brecht by Meg Mumford
Michael Chekhov by Franc Chamberlain
Jacques Copeau by Mark Evans
Etienne Decroux by Thomas Leabhart
Jerzy Grotowski by James Slowiak and Jairo Cuesta
Anna Halprin by Libby Worth and Helen Poyner
Rudolf Laban by Karen K. Bradley
Robert Lepage by Aleksandar Dundjerovic
Ariane Mnouchkine by Judith G. Miller
Jacques Lecoq by Simon Murray

Future volumes will include:

Antonin Artaud

TADEUSZ KANTOR

Noel Witts

Routledge
Taylor & Francis Group

LONDON AND NEW YORK

First published 2010
by Routledge
2 Park Square, Milton Park, Abingdon, Oxon OX14 4RN

Simultaneously published in the USA and Canada
by Routledge
270 Madison Ave, New York, NY 10016

Routledge is an imprint of the Taylor & Francis Group, an informa business

© 2010 Noel Witts

Typeset in Perpetua by
Book Now Ltd, London

Printed and bound in Great Britain by
TJ International Ltd, Padstow, Cornwall

British Library Cataloguing in Publication Data
A catalogue record for this book is available from the British Library

Library of Congress Cataloging-in-Publication Data
A catalog record for this book has been requested

ISBN10: 0–415–43486–6 (hbk)
ISBN10: 0–415–43487–4 (pbk)
ISBN10: 0–203–86536–7 (ebk)

ISBN13: 978–0–415–43486–7 (hbk)
ISBN13: 978–0–415–43487–4 (pbk)
ISBN13: 978–0–203–86536–1 (ebk)

For Krys

CONTENTS

PLATES

Plates are located between pp. 66 and 67.

ACKNOWLEDGEMENTS

Anyone studying the work of Tadeusz Kantor in English must first acknowledge the pioneering work of two Polish scholars, Krzysztof Plesniarowicz and Michal Kobialka, whose material has proved essential to the writing of this book. Their closeness to Poland and Polish has meant that I have been able to incorporate authentic voices. But we must also acknowledge the foresight of Tadeusz Kantor himself in setting up in the 1980s the Cricoteka documentation centre in Krakow, the staff of which have been unstinting in their help to me. Natalia Zarzecka, the current director, and Tomasz Tomasewski have in particular given of their time and information. Without the crucial help of Anna Halczak, the manager of the archive, and all her editing work over the years, plus the work of Bogdan Renczynski, I would have had a much more difficult, if not impossible task. Jolanta Janas at ulica Sienna has given much time to allow me to see the films, videos, and DVDs of Kantor's work, and I am also grateful to Andrejz Welminski, one of Kantor's longest-standing performers, for sharing with me his memories of Kantor's work as well as talking to me about his own teaching strategies. I thank Marie Vayssière and Ludmila Ryba – both members of Cricot 2 – for permitting me to discuss their teaching methods while they were conducting a workshop with international actors in Krakow in 2008.

Over the years I have had conversations with Wiesław Borowski of the Foksal Gallery in Warsaw, one of Kantor's foremost friends, and with Krzysztof Miklaszewski, a founding member of Cricot 2, who published his own book of interviews with Kantor in 2002. Martin Jenkins, then a BBC Radio drama producer, encouraged me to make a Radio 3 documentary with him about Kantor in 1994. Zofia Kalinska, one of Kantor's first and most famous performers, gave an early insight into his methods at the CONCEPTS Symposium held in Krakow in 1998, at the time when Maria Stangret-Kantor, Kantor's widow, allowed us to meet at their house in the countryside at Hucisko. At that time Krzysztof

Plesniarowicz, as director of the Cricoteka, enabled the symposium to go ahead, becoming the first such UK-sponsored Kantor event in Krakow. Richard Demarco, of the Demarco European Art Foundation in Edinburgh, has been a constant source of much information and comment on Kantor's groundbreaking visits to the Edinburgh Festival in the 1970s. The Centre for Performance Research in Aberystwyth provided much information in the form of a conference in the 1990s.

But it is probably the films of both Andrejz Wajda and Andrejz Sapija that have been the most influential in enabling the memory of the live performances of *The Dead Class* and *Wielopole, Wielopole* and many others to be rekindled; and once again we have Kantor himself to thank for making sure all his major shows were documented.

Specially I must thank Andrea Cusumano, of the University of the Arts, London, for setting up and conducting a series of 'live' Kantor-inspired projects over three years in Krakow at the Krzysztofory Gallery, thus ensuring the Kantorian influence continues, and for sharing with me some of his exercises for students; also Pete Brooks, of Central St Martins, University of the Arts, London, for encouraging these projects to take place.

I would like to thank Jozef Chrobak (and his translator Dominika Pietrzykowska) for allowing me to use and adapt his list of sites in Krakow associated with Kantor and which appears as an Appendix. Thanks also to Franc Chamberlain, the editor of this series, for his patience.

Finally I am grateful to the many students in several countries who, over the years, have been inspired by showings of *The Dead Class* and *Wielopole, Wielopole*, who took part in the Krakow Kantor shows, and whose enthusiasm finally convinced me and others that there was a need for this book; and to my wife Krys, whose half-Polish family gave me the excuse for many visits to the wonderful city of Krakow, Kantor's major stamping ground.

Extracts appear from *The Dead Memory Machine: Tadeusz Kantor's Theatre of Death* by Krzysztof Ple niarowicz (translated by William Brand) European Contemporary Classics (Series Editor: Richard Gough), published by Black Mountain Press. Black Mountain Press is a division of the Centre for Performance Research Ltd. This book can be purchased from the Black Mountain Press bookshop (http://www.thecpr.org.uk/shop/blackmountain.php).

BIOGRAPHY AND CONTEXT

INTRODUCTION

Stanislavsky, Meyerhold, Brecht and Beckett – four of the great pioneers of twentieth-century theatre practice – all lived through periods of history and historical events which influenced their lives and work, and it is true to say that Russia, Germany and France during the Second World War could all be described as crucibles from which emerged new performance practices and key roles for the theatre and its relation to society. But of all European countries none has had such a chequered and violent history as Poland, which has been described as being on one of the 'faultlines' of Europe where, over 200 years and more, the interests of the nearby countries – in particular Germany, Russia and Austria – have often been bloodily played out. In the centre of Europe, surrounded by powerful neighbours, most of whom had imperialist pasts, Poland has had fluctuating borders: it changed from being a huge state in 1634 to a non-state from 1939 to 1945, and finally to a moderate-sized country after 1945. Any examination of its history will find maps of different shapes, names in different languages, countries invaded or invading, and treaties broken or established; indeed, it was probably the most disturbed European nation of the twentieth century.

Tadeusz Kantor, born in 1915 during the course of the First World War, lived through four turbulent periods of Poland's history, all of which influenced his attitudes, his ideas and his performance practice

to such an extent that it is impossible to understand any of his key performances without being aware of the historical events that shaped them. Therefore, as well as recounting the major events of Kantor's own life in this chapter, we will attempt to contextualise these by reference to historical events as they occurred at four major points in the twentieth century. The first is the period and consequences for Poland of the First World War, from 1914 to 1918; the second is the first period in the twentieth century when Poland was independent – from 1928 to 1939; the third is the period of the Second World War, from 1939 to 1945, when the country was occupied by the Nazis; and the fourth is from 1945 to 1990, when Poland was a communist country broadly controlled from Moscow. In the light of this history it is not surprising that Kantor's attitude to the idea of biography was – as he suggested in his last theatre piece, *Today is My Birthday* – that any single interpretation simplifies too much:

> An artist's life and an artistic process escape the strategy of biography, which seeks to impose restrictive and restricting temporal boundaries on them. They should never be reduced to being 'texts' which are assigned locations and predetermined names. As the transformations in Kantor's manifestos and his productions poignantly illustrate, any desire to provide a historical and social map will immediately be ruptured by the thoughts, events, objects, and people who emerge, disappear, and re-emerge to present their conflicting claims, testimonies, and fragmented (his)stories.
>
> (Kobialka 1993: xix)

These thoughts come as a result of living through times where identities, relationships, employment and artistic opportunities were all subject to the changing and volatile political conditions as they emerged. Nevertheless the period through which Kantor lived, located at a European crossroads of culture, religion and politics, gives us both a need and an excuse to relate his work to this history.

POLAND 1914–18, THE FIRST WORLD WAR

By 1914 Poland had been at the mercy of a rivalry between the Russians, the Germans and the Austrians that went back well over 100 years. The many partitions of the country between those adversaries and the resulting multi-ethnic composition had left a burgeoning nationalism which had resulted in a series of risings and rebellions over the years. In 1914,

although the outbreak of war had no connection with Polish problems, the country in effect became a battleground with Germany fighting Russia, and one of the crucial images of Kantor's theatre – soldiers marching and shooting – became etched on the memory of the nation.

Tadeusz Maria Kantor was born at Wielopole Skrzynskie, Poland, on 16 April 1915, the son of Marian Leon Kantor-Mirski and Katarzyna Berger Kantor. Wielopole is situated 130 kilometres east of Krakow, and is roughly 100 kilometres from the Polish border with Ukraine, part of which was Polish until the end of the Second World War. To the north is the main road from Krakow to Rzeszow and Przemysl, and eventually to Lvov (now in Ukraine), while to the south lie the Bieszczady Mountains, today a major tourist destination in the new Poland of the European Union. Wielopole in 1915 was a *shtetl* – a small provincial town – but with a Jewish majority, at the back end of the then Austro-Hungarian Empire. In 1939, 60 per cent of the population was Jewish. Kantor said of it:

> It was a typical eastern small town or *shtetl*, with a large market square and a few miserable lanes. In the square stood a chapel, with some sort of saint for the Catholic faithful. In the same square was a well near which Jewish weddings were held, primarily when the moon was full. On one side stood the church, the rectory, and the Catholic cemetery, and on the other the synagogue, the narrow Jewish lanes, and another cemetery, somewhat different. Both sides existed in harmonious symbiosis. ... Aside from its everyday life the town was oriented toward eternity. ... And the children from the countryside and the town painted, put on plays, and were artistic without even being aware of it.
>
> (Plesniarowicz 2001: 11)

The social makeup of Wielopole meant that this must have been one of the corners of Europe where Jews felt at home, where, in the words of the historian Norman Davies, 'Almost every Polish family possessed Jewish friends or relatives, traded in Jewish shops, consulted Jewish doctors or lawyers, or drank beer in the local Jewish tavern' (Davies 2005: 191).

Kantor's grandmother, Katarzyna, arrived in Wielopole when her husband Josef died, to stay with her half-brother, who was the priest there; her daughter, Helena Kantor, also moved there to escape the chaos of the First World War. But Wielopole was in the direct line of German troops fighting the Russians at Gorlice in 1915, the same year that Tadeusz was born in the rectory, into a world of religion which had an ambiguous relationship with the war.

Wielopole at that point was in the area known as Galicia, north of the Carpathian Mountains between Krakow and Lvov. From time to time it was occupied by both Austria and Russia, and the town would have experienced the criss-crossing of soldiers and military units from both countries. By 1916 there were 1.9 million Poles fighting in the war, which eventually left 450,000 dead, images of whom appear from time to time in Kantor's work. However, in February 1917 the Russian Revolution took place in St Petersburg, one result of which was a proclamation, made on 30 March, of an independent Poland, where Russian state property was to be transferred to Polish control. It is difficult to exaggerate the importance of this to Poles, who for years had been condemned to dream of an independent nation, with only their – often forbidden – nativity scenes at Christmas, and ceremonies to mark weddings and funerals. Kantor remembered later that he and his sister would re-enact them at home.

Marian Kantor was drafted into the Austrian army at the start of the war, though he was later transferred to the Polish Legions, the volunteer units organised by Josef Piłsudski, who was to become one of Poland's most famous military heroes. At the end of the war, however, Marian Kantor did not return to his wife and children in Wielopole, but took part in an anti-German uprising in Silesia, where he was decorated with the Polish Cross of Valour and the French de Victoire order. It seems that he settled with another woman and taught in schools in the region. In spite of this absence from his son's life, Marian often appears as a recurrent character in Kantor's work, as a dysfunctional soldier.

POLAND 1918–39, TWENTY YEARS OF INDEPENDENCE

David Lloyd George, the British prime minister, referred to Poland in 1918 as a historic failure, having 'won her freedom not by her own exertions but by the blood of others'. Poland 'was drunk with the new wine of liberty supplied to her by the Allies', and 'fancied herself as the resistless mistress of Central Europe'. With insults like these being liberally thrown about by a Western statesman, it is not surprising that Polish independent art, expressing a restless experimentation, should assert itself between the wars in an intense way, with the work of the writer Witkiewicz, the painter Maria Jarema and the composer Karol Szymanowski, as well as the theatre and art of Kantor.

During this period of independence there were six border wars in which Poland fought against neighbouring countries, combined with a series of holding treaties and optimistic acts of non-aggression. The Battle of Warsaw in 1920 was followed by the Treaty of Riga in 1921, made with what was by then Soviet Russia. Pacts of non-aggression were signed with the USSR in 1932 and with Germany in 1934. The following year saw the death of the key figure in all this, Josef Piłsudski, the head of state. All these events were part of the birth pangs of a state which had been trampled on for centuries, and demonstrate well enough what Poland was up against even after it had been granted its independence. Once again its geographical position at the centre of Europe had to be strongly guarded by a variety of military means. But finally, in 1939, came the last straw, with the invasion of Poland by Nazi Germany, thus crushing the optimism of the independent country.

After Poland's defeat by the Germans in 1939, Kantor's father Marian joined the Union of Armed Struggle resistance movement, but was arrested by the Germans on 9 November 1940 for distributing an underground newspaper. He was transferred to Auschwitz concentration camp on 20 February 1942 and his family in Tarnow heard of his death on 4 April 1942. Marian Kantor, in spite of his absence from Tadeusz's life, became an important character in his son's theatre pieces: as Marian/The Recruit/The Bridegroom in *Wielopole, Wielopole*, in the Auschwitz scene in *I Shall Never Return*, and in the family photograph that comes to life in *Today is My Birthday*.

Kantor's first school was in the village at Wielopole:

> where he sat on a straight wooden bench marked with penknife carvings (just like the bench he created for his play *The Dead Class*). He sat among other children his age, who were barefoot and dressed in 'raggedy homespun trousers and shirts'. These children snatched time for schooling between work in the fields and chores around the farm.
>
> (Plesniarowicz 2001: 17)

However in 1925 Helena and her children also moved to Tarnow, where Tadeusz attended the Kazimierz Brodzinski First Gymnasium. Tarnow is an old city with a grand central square and an educational tradition which goes back to the 1500s. In the twentieth century the town's significant and long-standing Jewish population was a target for the Nazis, and there are still a series of Jewish monuments around the town. The Kantor family would have relished the move from Wielopole to a larger and better

connected place, nearer the provincial capital Krakow, with a cultural tradition which included a significant contribution before the Second World War from the 40 per cent of the population that was Jewish.

Kantor apparently did well there, particularly in humanities subjects, and gave private lessons in Latin and Greek. Here he both made his first forays into painting and visited the famous Cloth Hall in Krakow, where the huge canvases of the nationalist painter Malczewski were on display. He was particularly struck also by the work of Siemiradzki, whose gigantic front curtain was in the Słowacki Theatre and which upstaged the performances from Kantor's point of view. Already his interest in the theatre was beginning to collide with that in painting. At that time also, in December 1932, Kantor designed and painted the stage set for the third act of Wyspianski's play *Wyzwoleni* (Liberation) and for the fourth act of another, *Acropolis*, both of which were performed by an amateur school troupe in Tarnow's Sokol Hall.

In June 1933, having passed all his exams (he did particularly well in Latin and Greek), Kantor moved with the family to Krakow, where they rented a flat with his sister, Zofia. He began studying in the Faculty of Law and Administration at the prestigious and old-established Jagiellonian University, but left after two weeks and in October 1933 became a student at the Academy of Fine Arts, where he remained until 1939.

Krakow is the ancient capital of Poland, where kings had their residence over the centuries. With its aristocratic and artistic air, its ancient buildings and medieval street plan, the city is at least as impressive as Prague or Budapest. Its Main Square is dominated by the sixteenth-century Cloth Hall or *sukiennice*, which is unparalleled in Europe. When Kantor moved there in 1933 Krakow was at the height of its artistic fame, with the *Młoda Polska* (young Poland) art movement, led by Stanislaw Wyspianski and Jacek Malczewski, the Słowacki and Stary theatres, and a flourishing musical scene led by Karol Szymanowski. It also had the distinguished art school, where Kantor studied painting and stage design with Karol Frycz, one of Poland's great scenic designers. This allowed him to see performances at the Słowacki Theatre. But at the same time he began to learn about the Russian director Vsevolod Meyerhold and the specific work of the designer Oscar Schlemmer at the Bauhaus Art School in Germany. Schlemmer had pioneered a stage workshop where painters and designers created stage works. Ironically, Kantor's discovery of Schlemmer was in the year in which the Nazis finally closed the Bauhaus in Dessau.

Round about the same time Kantor began to discover the work of Stanislaw Witkiewicz, another extraordinary Polish artist who crossed boundaries between theatre and painting, and began his acquaintance with the work of the novelist Witold Gombrowicz and Bruno Schulz, who was a painter and short story writer. This Polish literary / visual tradition, allied with the experimental theatre work of Meyerhold and the cross-disciplinary work of the Bauhaus, must have given Kantor confidence in developing what would be his unique contribution to twentieth-century theatre practice.

In 1937, on the eve of the Second World War, Kantor founded a group called the Ephemeral Marionette Theatre, which gave a performance of *The Death of Tintagiles* (1894), written for marionettes by the Belgian playwright Maurice Maeterlinck. The play had been staged by Meyerhold at the Moscow Art Theatre in 1905, using live actors in still poses. Kantor's production is remembered for the marionettes being 'simplified geometrical forms of triangles and rhomboids' and the prevailing colours being black and grey, with a moveable moon cut out of tin foil. Kantor also, according to a witness, attached particular importance to a special intonation and way of sounding the words, which he worked out for each character. Around this time he may have come across the work of the British theatre designer and visionary Edward Gordon Craig, who pioneered the idea of theatre as primarily a visual experience, and who, in a notorious essay, had proposed that a marionette could be a more reliable stage presence than a live actor – a view which was taken up by Maeterlinck in several of his marionette plays. By now Kantor was assisting the designer Frycz in Krakow in his productions as well and beginning his own independent theatre practice. At this point he saw that, in Russia:

> the constructivists supposed that the social revolution would be followed by an artistic revolution. The war came instead, and it destroyed all hope of combining the two revolutions. And that is the starting point for my theatre and my art.
> (Plesniarowicz 2001: 29)

POLAND 1935–45, THE SECOND WORLD WAR

From 1939 to 1945 the Nazis occupied Poland, and the territory taken over by them was referred to as the New Reich. The south of the country, with Krakow as its centre, became known as the General

Government. Martial law was in force in all the occupied parts of the country, and 'death' or 'concentration camp' were the punishments for any kind of offence. Hans Frank, who had been Hitler's lawyer, became governor of Krakow and lived in the former residence of the kings, Wawel Castle, overlooking the River Vistula. At the same time Poland became the major place where Reichsführer-SS Heinrich Himmler began to devise ways of putting his racial theories into practice: 'The removal of foreign races from the incorporated eastern territories is one of the most essential goals . . . We either win over the good blood we can use for ourselves . . . or else we destroy that blood' (quoted in Davies 2005: 329). The mechanisms for this destruction were the Auschwitz-Birkenau concentration/extermination camp, approximately 60 miles from Krakow, the Jewish ghetto in Krakow, and the Plaszow concentration camp on the outskirts of the city. The activity of establishing these was being undertaken while Kantor was living in Krakow, and for him must have seemed something like a rerun of the situation in his home village of Wielopole after the First World War, where identity was also emasculated, though to a lesser degree. Krakow, as Poland's major cultural centre, had always seen itself as the force for preserving Polish sensibility and multi-ethnicity, something that became a vain hope as the Nazis tightened their hold and built the Jewish ghetto and the camps.

One might well enquire how a 24-year-old emerging theatre-maker with Kantor's avant-garde and experimental interests coped during this period. He was living two lives, one the official life of the street, the other the artistic life of the underground. At one point he tried to describe how the events of the war influenced both him and his friends, and how for artists a connection with the outside world of the European avant-garde was important as a framework within which to work and survive:

> the group of young artists, from among the best Polish painters and theoreticians who emerged after the [First World] war, did not take up any sort of national ideal in those times of horror. Instead, and in the face of all logic, they turned to the international avant-garde, which has shown the way for art in Poland to this day. This occurred in an epoch of genocide unprecedented in history, at the very centre of the harshest terror, cut off from the rest of the world.
>
> (Plesniarowcz 2000: 32)

In fact Kantor and his family lived for several years near the walls of what was the Jewish ghetto, set up by the Nazis in the Podgorze district of the city. During this time Kantor was allowed to work for the Institut

für Deutsch Ostarbeit, after which he was employed as a 'decoration painter' in the State Theatre of the General Government, which was the name the Germans gave to the Słowacki Theatre. Krzysztof Plesniarowicz describes Kantor's physical situation:

> the theatre workshops were then located at ulica Kupa 18, in the ruined Izaaka Synagogue in the Kazimierz district, which was abandoned after the deportation of the Jews. In 1942 Kantor, his mother, his sister, and his brother-in-law were resettled at ulica Wegierska 10/27 in the Podgorze district. The building stood within the original ghetto established by the Germans; after the reduction in the size of the ghetto, Kantor now lived next to the walls of the 'closed' district. He was an eyewitness to the Holocaust.
>
> (Plesniarowicz 2001: 35)

By 1942 Kantor had established a group of artists who created a clandestine theatre – the Independent Theatre – and met in private apartments all over Krakow under the Nazi occupation. They gave each other lectures on, among other subjects, Cezanne, Cubism, and Futurism, and they read works by Wyspianski, Kafka, Gombrowicz, Schulz and Witkiewicz, as well as other avant-garde poets.

The first full production of the Independent Theatre was Julius Słowacki's *Balladyna*, an ironically tragic romantic folk-tale which tells a story of a country girl whose craving for power plus a multitude of crimes allows her to reach the royal throne. For Kantor this became an opportunity to create an abstract production. He used geometrical forms, circles, arcs, right angles, and materials such as tin sheet, black tar paper and fabrics to create a sculptural structure. One of the characters, Goplana, was fitted with a golden string which vibrated and gave off a moaning sound. Inside the structure sat an actor who had to speak into a washbasin in order to achieve a metallic tone of voice, and so on. While the performances of *Balladyna* were taking place the Nazis were rounding people up, but somehow the Germans managed to avoid the particular apartment in which they were going on. The impact of the production was strong and was described as 'an authentic sensation in underground Krakow, which had not seen for years a production that was at once so mutinous and so splendid' (Plesniarowicz 2001: 38).

Balladyna can be viewed as Kantor's theatrical response to his wartime exposure to abstract and symbolist art. It is both as a way of encompassing what he came to see as the visual imperative of theatre and of acknowledging that theatre and visual art are complementary.

The production was also a means of linking his work to other European avant-garde artists and a means of escaping the more conventional work that was being shown in Krakow's official theatres. Working in this manner during the war was one way of remaining in touch with artistic currents outside the occupied country.

The next production of the Independent Theatre was of Wyspianski's last play, written in 1907, *The Return of Odysseus*. Although Wyspianski had conceived the Greek hero Odysseus returning as a war criminal and a traitor, Kantor presented him as a German soldier retreating from Stalingrad, the great siege of which had been a defeat for the Germans, and which had already taken place when the production opened. The opening scene was Odysseus returning in a muddy uniform and helmet to the strains of a German parade march. The production had to change venue several times to escape Nazi prosecution. For his set Kantor created a room destroyed by war – which was a kind of authentic reality, since there were thousands of such rooms in Poland at the time – which was filled with found objects discovered in nearby ruined houses, and also contained a barking loudspeaker intended to imitate the sound of the wartime communiqués from the German authorities. The contrast with *Balladyna* was important, for Kantor was now already looking at ways of expressing human reality on stage, confronting Odysseus with the worn realities of Europe at the end of a cataclysmic war. He wrote in his 'Credo' in 1944:

> I do not want my Odysseus to move around within an illusory dimension but within and without our reality, our objects – that is objects that have certain specific value for us today – and real people, that is people who are in 'the auditorium'.
>
> (Kobialka 1993: 35)

Such was its importance for Kantor, this production was restaged at the Bagatela Theatre in Krakow in 1974. He wrote of it:

> *The Return of Odysseus* established a precedent and a prototype for all the later characters of my theatre ... there were many of them. The whole procession that came out of many productions and dramas – from the Realm of Fiction – all were 'dead'; all were returning into the world of the living, into our world, into the present.
>
> (Plesniarowicz 2001: 43)

This may be the first mention of the idea of a theatre of death, which was to become one of the main philosophical tenets of Kantor's work over the

coming years: the notion that all representation on stage is of something that is no more and has been resurrected from memory. Indeed, the two themes of death and memory permeated Kantor's theatre material until the end of his life. It is arguable that living and attempting to work in the occupied city during the Second World War was instrumental in leading him towards what is a respect for death and memory. No one who does not know Poland can possibly envisage what it must have been like for an artist to carry on functioning a few kilometres away from Oscar Schindler's factory and the reality of the death camps. In some ways it is almost incredible that a group of artists could find the motivation to produce theatre work at all under such conditions. No wonder that Kantor returned to regular key themes that represented not only an aesthetic position, but a recognition of what the past and death meant for a post-war Poland dominated by the result of another kind of dictatorship, that of communist Russia.

POLAND 1945–90, THE COMMUNIST PERIOD

Poland became communist as a result of the deliberations by the victorious countries at the end of the Second World War. At a conference in Yalta in the Crimea the British prime minister Winston Churchill and presidents Roosevelt (United States) and Stalin (Russia) divided Europe in half according to the pre-war boundaries – with the exception of Germany, which was divided into West and East Germany. As a consequence of Russia's help in defeating Hitler, which had resulted in a loss of 27 million Russian lives, Stalin was given the whole of Eastern Europe as the communist sphere of influence. Once again Poland found itself on a European faultline, geographically situated between the eastern part of Germany and Russia, thus next to two historical enemies. The situation now became harsh once again, with much of life and living heavily controlled, with restrictions on travel, with artistic censorship, and with membership of the communist party being seen as an 'advantage'. Much of Kantor's most famous work was created during the 1960s and 1970s, during a period in Poland in which there was a sense of resignation. There was nothing much anyone could do about the system, so it would be as well to go with the flow. And, compared with the majority of the countries of Eastern Europe, Polish independent sensibility meant that the country was more liberal than most. It is no surprise, therefore, that a series of riots and demonstrations through the 1970s led eventually to a general strike – unheard of in a communist country – and to the founding in 1980 of

Solidarity, the first independent trade union. Two years before that, in 1978, Cardinal Karol Wojtyla had been elected the first Polish pope, an event seen as both a triumph for the religious Polish nation and a vindication of the Polish spirit.

The Solidarity union was based at the shipyard in Gdansk and led by a feisty worker called Lech Walesa, later to become president of Poland. He encouraged the union to grow in strength and confidence to such a point that in 1980 there was a threat of Soviet intervention in the face of growing Polish political confidence, which was then followed by a declaration of martial law by the government, led by General Jaruzelski. At the same time President Gorbachev of Russia initiated his ideas of 'glasnost' and 'perestroika', which eventually led to the collapse of communism in Eastern Europe. Through all this time Kantor remained in Krakow, creating theatre work that spoke to Poles of Poland and of Polish identity and history, and which became symbols of Polishness underground, whereas above ground communist officials were still prowling the streets.

Immediately after the Second World War, in 1945–6, Kantor was employed as an assistant stage designer at the Stary Theatre, one of Krakow's finest theatres, today still housed in a striking art nouveau building in the centre of the city. He also created sets for other theatres in Krakow, where one critic thought that the designs often outstripped the work of the directors. But in the years following this Kantor devoted himself more and more to his painting. He exhibited together with many artists who would in future take part in his theatre work, initiating a European precedent for visual artists working in theatre. After the liberation of Poland by the Russian Red Army in 1945, Kantor married Ewa Jurkiewicz, who had been involved in the young artists group and been a member of the Independent Theatre. They had one daughter, Dorota, who was born in 1955. At that time in the studio in his flat there was a certain black umbrella, 'old, tattered, and bent', to which Kantor became attached to such an extent that it became a key element in his painting. There is a series of pictures where umbrellas are fixed to the canvas, and many of his drawings include this object, though it does not appear much in his theatre work.

In 1946 Kantor won a Polish Ministry of Culture and Art scholarship to travel to Paris for six months. This was his first visit to the key centre of twentieth-century European art, and he was able to see the huge collections at the Louvre as well as the display of the impressionists in the Jeu de Paume. He saw the work of Picasso, Kandinsky, Klee and Ernst,

thought Miro's paintings were like the writings of an extinct culture, and felt very powerfully the memories of wartime cruelty present in Paris. France had also been occupied by the Germans during the war, when Samuel Beckett and his wife had worked for the French Resistance movement. Kantor's visit, in spite of the shock of recognising remnants of the occupation, reconnected him to the European avant-garde, which meant that returning to communist-dominated Krakow, with all its restrictions, was even more difficult and depressing. However, on 1 October 1947, Kantor took up an appointment as junior professor in the State Higher School of the Plastic Arts in Krakow – the historic art school – where he held painting classes. The following year he was involved in a big exhibition of modern art in the Palace of Art in Krakow, which included lectures, concerts and various events. This turned out to be the last display of alternative exploratory art in post-war Poland, as communist ideology, with its restrictions on experimentation in art, began to be asserted. It was shortly after this that the authorities, in common with most communist governments in Eastern Europe, imposed the Russian-created artistic doctrine of Socialist Realism.

Socialist realism had been proclaimed as part of the continuation of the Russian Revolution in 1920 in an attempt by the Soviet authorities, and Stalin in particular, to harness art to political ends. All art should portray the positive aspects of life and of communism and, by so doing, should help to persuade the population of the value of the communist cause. Gone, therefore, were all influences from Western Europe, which were seen as anti-communist, especially contact with the kinds of visual artists that Kantor had encountered in Paris. Socialist realism was to portray optimistic naturalistic life in theatre terms as well, or to display the key classic texts, which were felt to express the true spirit of man according to the communist analysis. So out went the work of Witkiewicz, and in came texts by many now forgotten names, as well as plays by Shakespeare, who was often seen as the anti-bourgeois writer who satirised the aristocracy. Kantor's attitude to all this was one of utter contempt, where state authorities were 'ruthlessly destroying and exterminating "abstract" tendencies, while promoting whole tribes of mediocre, zealous conformists and opportunists'. In fact his contempt for the communist ideals meant that his theatre work was never seen in any official venues, but always in alternative spaces with no connections with officialdom, a choice Kantor made as a gesture towards retaining the independent Polish spirit.

In the confused aftermath of war, and amid the imposition of alien forces that were bureaucratic as well as ideological, it was felt that employing an openly dissident artist at the art academy was courting trouble. So, in February 1949, Kantor was dismissed from his post, for 'the incorrect manner of teaching represented and practised' – a phrase which shows how far the more official educational institutions were being controlled by the government. However, he was still able to be employed as a scenic designer, and this meant that he gained experience while in his early thirties designing for both the Słowacki Theatre and the Stary Theatre in Krakow and for theatres in Poznan and Katowice. The list of productions for which he created designs included texts by Calderon, Shakespeare (*Measure for Measure*), Shaw (*St Joan*), Lorca and Alfred de Musset. After the death of Stalin in 1953, Kantor received a series of medals for his work as a stage designer, among them the Officer's Cross of the Order of Poland Reborn (1955), but his response to this was that such awards downgraded his painting, which for him was always his most important activity.

In May 1955 Kantor visited Paris again, this time with the Stary Theatre, which had been invited to the Theatre of the Nations season, itself a meeting point of European theatres which allowed companies from the communist countries to participate. It is worth commenting on these cultural exchanges which took place throughout the communist period. The Stary Theatre, with its solid and often very beautiful productions, toured abroad, representing the best of Polish theatre, something that was seen as nonpolitical and which disguised any images of suppression at home. The company also visited the London World Theatre season, although without Kantor, where it presented a display of theatrical technique that also managed to disguise any communist influence. For the government these tours were a good way of spreading 'good' news about Poland. If the theatre could be so good, then life must be OK back there, so went the crude analysis. Any attempt at dissident activity on the part of actors while away would result in the cancellation of any future visits abroad or even the loss of employment at home, so the government was on safe ground. In this way the privations endured by Poles were not visible on stage.

CRICOT 2 AND THE KEY PRODUCTIONS

On his return from Paris Kantor began a kind of painting which was near to action painting and which he called his 'informel' painting (from the

French *informelle*, 'shapeless'), and exhibited this work in Warsaw at the Zacheta Gallery. A major event occurred in 1953 with the death of Stalin, which was followed by a period of cautious cultural optimism in the communist world. In the autumn of 1955 came another key moment when Kantor founded, with Maria Jarema, another painter, the Cricot 2 Theatre, which was to make his name universally famous. The name harked back to the pre-war Krakow Cricot Artists Theatre (1933–9), the name 'Cricot' being a French-sounding anagram of the Polish phrase '*to cyrk*' – 'it's a circus'. In 1956, however, the Soviet leader, Nikita Khrushchev, made a secret speech to the twentieth party congress of the Communist Party in Moscow. In it he made an extraordinary denunciation of Stalin's activities and his management of the Communist Party, after which there was a slow softening of artistic censorship. It was during this period that Kantor met and fell in love with Maria Stangret, a student at the Fine Art Academy in Krakow, which caused him to dissolve his first marriage and exchange new marriage vows within the Polish Embassy in Paris in 1961.

The Cricot 2 company was in some ways an extension of Kantor's wartime Independent Theatre, composed as it was of artists, actors, musicians and poets. Its first production, given on 12 May 1956, was Witkiewicz's *The Cuttlefish*, directed by Kantor with costumes by Maria Jarema. Witkiewicz, who had come to prominence during the period of Polish independence, had been banned during Stalin's time, and so Kantor was the first to stage any of his texts since the war. He stayed loyal to the playwright for the rest of his life. During the first two decades of the existence of Cricot 2 the company owed much of its reputation to its method of 'playing with' Witkiewicz. After *The Cuttlefish* came *In a Country House*, *The Madman and the Nun*, *The Water-Hen* and *Dainty Shapes and Hairy Apes*. The last two were presented on the Fringe at the Edinburgh Festival in 1972 and 1973 under the auspices of the gallery owner and impresario Richard Demarco.

Kantor later explained that his idea was in no way to follow or interpret texts, but to have both the text and the action functioning as separate elements. The performances often began at 10 o'clock at night, as many of the performers were employed in the official Krakow theatres, this being seen as a symbol of new-found freedom after the strait-jacket of Stalinism. It is interesting to realise that, whereas in Poland in 1956 Kantor was able to begin the experimental work of Cricot 2, in the communist world as a whole there were also major stirrings of political discontent. In Hungary that year Russian troops brutally suppressed an

uprising of the people of Budapest, which became one of the defining moments of the Cold War, while in Poland the election of Wladislav Gomułka as president was seen an element in the slow thawing of Russian control over the country. For the first time, as the British historian Norman Davies points out, Moscow's claims to automatic control of another country's ruling party had begun to be questioned.

At that time also there were many efforts to try and register Cricot 2 as an official company, but these all ended in failure, mainly on account of the fact that it was evidently seen as irresponsible. Plesniarowicz relates that there was an allegation that Cricot 2 spectators had damaged the sanitary facilities at the Artist's Club on the night of a performance, and there exists a letter from the authorities billing the company for the cost 'of repairing the broken washbasin in the toilet'.

In 1958 the Krzysztofory Gallery was opened in the cellars of the Gothic Krzysztofory Palace, just off Krakow's Main Square. Added to the gallery was a café which became the unofficial headquarters of the Cricot 2 group. Both gallery and café – somewhat updated – still exist, along with the area in which many of Kantor's productions were premiered. It is therefore to be added to spaces such as Brecht's Berliner Ensemble, Grotowski's Laboratory in Wrocław, Mnouchkine's Cartoucherie and Brook's Bouffes du Nord in Paris as a key place still extant where significant twentieth-century performances had their origins.

During the late 1950s Kantor once again began exhibiting paintings abroad in Germany, Sweden, France and the United States, where his work began to be bought by private collectors. It is interesting that, although his reputation as a theatre-maker has been prominent internationally, he was at this time recognised mainly as a key Polish visual artist. He reckoned himself that his fame as a theatre artist came only in 1972, but it was in the early 1960s that Kantor began to recognise that he was crossing the boundary between painting and theatre, the turning point being the first text that he staged in the Krzysztofory Gallery in December 1961. This was *The Country House* by Witkiewicz, where living sculpture met theatre: the performers were all crammed into a wardrobe, in which they played for half and hour 'jammed together like garments'. Kantor saw this as a trial run at translating the language of visual art or living sculpture into theatre. He used the same metaphor in the introduction to *Dainty Shapes and Hairy Apes*, where the audience had to fight their way into the theatre space through their coats left in the cloakroom. He said later in life to Denis Bablet:

> Whether it is theatre, or painting, or drawing, or a book – it all comes into being in a strange way, and I can do anything. You cannot say 'theatre ends here and painting begins here'. To me it's all the same.
>
> (Plesniarowicz 2001: 87)

The Country House was given thirty-three performances, and the Cricot 2 company now included mostly professional actors from the various theatres in Krakow.

The year 1963 was what Plesniarowicz calls a turning point in Kantor's life. He resigned from work as a stage designer but extended his work with Cricot 2 by directing Witkiewicz's *The Madman and the Nun* at the Krzysztofory Gallery according to the principles of the Zero Theatre, the manifesto for which was published in that year: 'This process means dismembering logical plot structures building up scenes, not by textual reference but by reference to associations triggered by them, juggling with CHANCE, or junk' (Kobialka 1993: 60). An example of this process was that for this production Kantor constructed a mobile in the form of a pyramid of carefully joined-up chairs – the *Machine of Annihilation* – which came from the Dominican church in Krakow, 'found' by Kantor as new pews were being constructed. This object when set in action drowned out the sound of the performers, pushing them off the small stage, and making it impossible for them to perform properly.

In November 1963 Kantor held a one-man show in the gallery with the intention of enlarging the concept of a work of art by including objects used in his stage work, as well as several hundred drawings which were hung up on washing lines and placed in old baskets. There were also costumes and objects from productions, together with a reconstruction of the 'poor room of reality' from *The Return of Odysseus*. The following year was notable for the appearance of another of Kantor's key concepts – that of *emballage* (or *ambalaz* in Polish). He had already produced his *Emballage Manifesto* between 1957 and 1965, where he wrote: 'Emballage, Emballage, Emballage / Its potential is limitless' (Kobialka 1993: 79). *Emballage* (a French term meaning 'packaging') became for Kantor a new means of artistic process whereby objects, people or works of art are eventually hidden or made inaccessible. This had some parallels with the artists of the Dada movement, who had provoked audiences with physical objects. In this case the provocation came with the hiding of the object in an *emballage*, which in some cases were parcels or large envelopes, connected not simply to Kantor's static

art forms but to his collection of Happenings and Wanderings, which we now examine.

Kantor, in his visits to the United States, had already come across the concept of the Happening, a term invented by Allan Kaprow, whom he met in 1965. These were described as 'non-matrixed performances', a concept similar to that used by the Dadaists earlier in the twentieth century, especially in their performances in Zurich as part of the programme of the Cabaret Voltaire during the First World War. It very much paralleled Kantor's Zero Theatre, in that it used chance structures and everyday events and sought to sensitise audiences to unexpected actions in unexpected places. Kaprow summed it up when he wrote: 'The line between art and life should be kept as fluid and perhaps as indistinct as possible' (Huxley and Witts 2002: 260).

Kantor's great collaborator over his Happenings was the newly opened Foksal Gallery in Warsaw, run by a group of art critics, in particular the writer Wiesław Borowski. It still exists, having become one of the most important Polish galleries to survive the communist period. In *The Letter*, created in January 1967, an enlarged envelope measuring 14 metres long and 2 metres high was transported through the streets of Warsaw by seven authentic postmen, to be received by the audience at the gallery. This alluded to the way in which letters during the communist period – often tampered with – were an important method of ambiguous communication of official demands.

In August of the same year Kantor staged *The Sea Concert* as part of a festival at Lazy, on the Baltic coast. This was one of five sections of a larger Panoramic Sea Happening, which Plesniarowicz describes:

> Aside from the figure [Kantor] in tails directing the symphony of the waves, the happening also included *The Raft of the Medusa*, a replica in happening form of Gericault's famous painting the *Erotic Barbujaz* in which the bodies of female volunteers were rolled in sand mixed with oil and tomato sauce, *Agrarian Culture in the Sand* in which newspapers were planted on the beach, and the *Sinking* of a crate containing 'important documents 'from the Foksal Gallery. In the organisers' report they wrote that 'the outdoor event had a very good press, which stressed the boldness of the artists and the authorities'.
>
> (Plesniarowicz 2001: 102)

The Anatomy Lesson Based on Rembrandt (1968) presented a dissection of clothing on a person lying in an operating theatre, confirming Kantor as a major figure in the history and extension of Allan Kaprow's original

concept of the Happening. In 1968 Kantor once again accepted a professorship at the Fine Art Academy. It was also the year of the major political revolt against Russian domination in Czechoslovakia, which bordered on Poland. The consequent Russian invasion of Czechoslovakia and the reimposition of Russian-backed political leaders showed yet again that any anti-Russian dissidence in the Eastern bloc countries would be brutally dealt with. At the same time there was a virulent anti-Semitic campaign in Poland, with the Krzysztofory Café full of informers spying on students.

At this point it is worth mentioning some of Kantor's artistic contemporaries whose work was already well known in the West, and whose publications helped the world understand that Poles were both struggling to face down Russian domination and were also able to write material which could be seen as unambiguous criticism. The dramatists Sławomir Mrozek, Tadeusz Rosewicz and Witold Gombrowicz, the poet and critic Czesław Milosz, the film-maker Andrejz Waida, composers Witold Lutosławski and Krzysztof Penderecki, and theatre maker Jerzy Grotowski formed a major framework for this international reputation. It is also interesting that in the major history of Poland in the twentieth century, *God's Playground*, written by the British historian Norman Davies, there is no mention of Kantor and Cricot 2, which perhaps shows how clever Kantor was in keeping his work below the parapet of public recognition. However, this was all to change when the company started to tour outside Poland.

INTERNATIONAL FAME

Kantor's work was first shown to a foreign audience in 1969, when the Cricot 2 company went to Rome with *The Water-Hen* of Witkiwewicz for the Premio Roma Festival. Michal Kobialka describes the premiere in Krakow:

> For *The Water-Hen* Kantor converted the Krakow's Krzysztofory Gallery into a space that looked like a poorhouse. The whole space was filled with mattresses, old packets, ladders, wooden partitions, stools, chairs, and so on in such a manner that there was no separation between the audience and the actors. The spectators were under the influence of the same problems and moods as the actors. A wandering group of travelers and their bags entered the space. As Kantor observed, 'for the time being, the actors do not have names'. Once inside they engaged in banal, every day actions and gestures so as to define themselves … the text of the play ceased to be perceived as material waiting to be

formed by a director or by space. Rather the text was treated as pre-existing or 'readymade' reality … significantly, the group of travelers did not begin to act out the parts of characters from the play. Instead they spoke the lines of the characters with different intonation and rhythm.

(Kobialka 1993: 298)

These manipulations prefigure the work of the American Wooster Group and the UK group Forced Entertainment, both of which seek to undermine an audience's expectation of what a theatre performance may be. However, in spite of the Cricot 2 group's success in being invited abroad, on their return they lost half their subsidy and Kantor's contract was terminated by the Krakow Academy of Fine Art. Political nervousness was once again stalking the streets of Poland.

The Water-Hen toured to Italy, France and Scotland, where Richard Demarco presented it at the Edinburgh Festival Fringe in 1972. Demarco later spoke of the resistance he encountered from the Polish Ministry of Art and Culture: 'They promised to cover all the costs if I invited Grotowski. When I asked about Kantor they said no such thing existed' (Plesniarowicz 2001: 104).

Michael Billington was one of the first UK critics to enthuse about Kantor: 'Alas, he and his 23 strong company return to Poland on Sunday. But if I were running an experimental theatre I would pull every string going to get them back' (*The Guardian*, 23 August 1972). Thus was the work of Kantor first received in the English-speaking world – with no translation, no subtitles, no real aid to understanding. While Kantor's transformations and imaginative interpretations of the work of a playwright were hardly known in the UK, the production worked an exciting spell on audiences that were ready for a break from solid naturalistic fare. As future visits to the UK by Cricot 2 were to confirm, Kantor's performances showed audacious ways of theatre-making never before seen in Great Britain or America.

In the following year, 1973, Kantor again took Witkiewicz's *Dainty Shapes and Hairy Apes* to the Richard Demarco Gallery in Edinburgh, where it received *The Scotsman* Fringe First award. By now the UK critics, led by Michael Billington of *The Guardian*, were waking up to the fact that in far-off Poland there were modes of theatre-making that completely avoided the Stanislavsky method, that 'played with' texts in contrast to 'being faithful to the author' – a favourite British expression – and that produced a form of theatre that defied classification. Most visual artists had no problems with Kantor's work, but for the text-heavy

creators of British theatre this material was a rather unwelcome revelation. There were, however, one or two critics who were able to see what was going on: 'You only have to look at the smiling, hawk-profiled figure of Kantor himself, orchestrating the action from its centre, to realize that the solemn absurdities of most avant-garde theatre would never get past that wry, quizzical gaze' (Michael Billington, *The Guardian*, 23 August 1972).

In 1974 *Dainty Shapes and Hairy Apes* was shown at the International Theatre Festival in Nancy and the Theatre National de Chaillot in Paris, as well as at the Festival of Arts in Shiraz, Iran, where three years earlier Peter Brook had shown *Orghast*, written in an invented language by Ted Hughes. Audiences had also seen the work of Grotowski there, but there is no record of how Kantor's work was received.

It is possible to see many of Kantor's early writings, most of which were in manifesto form, as rehearsals for his manifesto *The Theatre of Death*, which he published in 1975. He said to Denis Bablet:

> I noticed at a certain moment that reality in art is not the reality of life, but rather an imitation object. … I never returned to illusion, but I created something that was imitation reality. That is where the mannequins, the wax figures, come from.
> (Plesniarowicz 2001:117)

This is where Kantor for the first time shows how far he has departed from all the main traditions of European theatre in advocating non-linear forms and speaking of and dealing with the actor as object. He expresses here his concept of theatre as vision, as a process of parallel actions and events folding back on themselves – a concept that was to be made public on a grand and extensive scale with his next and most famous production, *The Dead Class*, first performed on 15 November 1975 at the Krzysztofory Gallery. In recollections of his holidays in the early 1970s at the seaside he came across:

> a humble, deserted school building. … It had but a single classroom. It could be viewed through the dusty panes of the two small, shabby windows. … I glued my face to the window pane. Long long did I look into the dark and dim depth of my memory.
> (Musial 2004: 66)

Rehearsals for the production had begun in December 1974, this time with a subsidy from the Culture Department at the Krakow City Hall.

It became the longest-running of any of Kantor's pieces (more than 1,500 performances in seventeen years), and was performed by professional actors from the Bagatela and Groteska theatres, together with painters. Over the years it was given in at least three different versions, with slightly changing interpolations of characters. It was the first version that was filmed by Andrejz Wajda in 1976, and which is now available in a cleaned-up DVD version. For many audiences all over the world *The Dead Class* became a symbol of Polish theatre, humour and survival. Although this was the time when Grotowski was retiring from theatre activity, it was nonetheless a revelation that there existed in Poland a diametrically opposed form of creating theatre. Much of the extensive student theatre that had visited the UK and other 'Western' European countries had contained ritualistic forms that linked them to Grotowski, or more political forms which linked to a tradition of agitprop theatre. Kantor's work was unique in its visual invention, in its lack of linearity, and in its obsessive Polishness. For most audiences, understanding little or no Polish, the performances became a kind of mime, but for those who understood the texts from Schulz, Gombrowicz and Witkiewicz that permeated the show it became a compendium of memory and a history of a nation constantly dominated by others.

The reception of *The Dead Class* was nothing less than rapturous. It was as if the scales had been lifted from the eyes of many critics. One noted 'an agony of expression which you don't find in the work of western artists', while another wrote that 'Kantor invokes a traumatic experience that has damaged us all: school'. Yet another spoke of the *Waltz François* as a 'schmaltzy café waltz, whose lilt, promise of some never-fulfilled hope of gaiety . . .'. The poetry of Kantor's visual and aural imagery seemed to speak to all nations. The piece won an OBIE (Off-Broadway Theatre) award in New York. It also won the Grand Prize at the Belgrade Festival in 1977, the Cyprian Norwid Critics Prize (Poland), the Mayor's Medal of the Commune di Roma, the Grand Prix, and the Puana Sujo at the Caracas Festival (Venezuela).

In late January 1979 came *Ou sont les neiges d'antan?*, a 'cricotage' lasting twenty-five minutes, where 'a line of life and death' was stretched across the centre of the stage in the Palazzo delle Esposizione in Rome. Around it was staged a grotesque wedding with a dead bride and twin cardinals dancing an Argentinian tango with mannequins. It is difficult to place this in the canon of Kantor's work except to suggest that even he needed to find a form to experiment with images from

time to time without the pressure of a long performance. He did this once again with *I Shall Never Return* in 1988.

In 1979 also came an invitation from the city of Florence to go there for a whole year to mount a new production, with all expenses paid. This solidified Kantor's links with Italy, which became a second home both for Cricot 2 and for followers of the work. Only some of the members of the company of *The Dead Class* went to Florence, so that Kantor had to recruit Italian performers for what was to become his next best-known theatre piece, *Wielopole, Wielopole*, a memory piece which evoked scenes, characters and issues from Kantor's childhood village in eastern Poland. The premiere took place on 23 June 1980. For the first time Kantor wrote his own text, much of which is concerned with memories of events and the confusion of memory, with actors as mannequins occupying a significant role. The piece evokes not only personal history but the military framework of war which so dominated Kantor's childhood. One English critic wrote of the piece: 'these are the little, ineffectual actions which fill our lives and eventually combine to form a pulsating rhythm of memory' (*Fulham Chronicle*, 12 March 1980).

Once again there was something in this Polish provincial material of universal meaning, for the piece then toured Italy, Great Britain, France, Poland, Switzerland, Venezuela, Germany, Spain, Mexico, the USA, Sweden, Finland, Argentina and Greece, winning another OBIE award in New York in 1982. It also received the Medal of the City of Lyon, and the Mayor's Gold Medal of Florence.

A MAJOR ARTIST FOR POLAND

At this point the Krakow municipal authorities finally woke up to the fact that a major artist was promoting both Poland and Krakow abroad and gave Kantor the premises of the recently opened Artistic Exhibitions Bureau Gallery at ulica Kanonicza in Krakow. This consisted of rooms, owned by Wawel Cathedral, on the ground floor and in the cellar of a newly renovated medieval town house. It became the home for the Cricot 2 archives, which Kantor called the Cricoteka, and which still exists in situ.

The Solidarity movement is often given credit for being the beginning of the end for communism in Europe, precipitating as it did a flood of dissident protest outside Poland. *Wielopole, Wielopole*, was performed at the shipyard at Gdansk, where the movement was founded, and

where it was disrupted by a heckler who thought it profaned national values. As a consequence Kantor requested the mayor to provide police protection for the show, which he did. He said later: 'it seems to me that there are only moments of some sort of historical accident, when life is accepted by art, or when art justifies life' (Plesniarowicz 2001: 125).

By this time Kantor himself had been honoured in several countries. In 1978 he was awarded the Rembrandt Prize by the Goethe Foundation in Basle, and in 1982, on the second anniversary of the birth of Solidarity, he accepted the Commander's Cross of the Order of Poland Restored from General Jaruzelski – though by this time Poland was under martial law in order to crack down on anti-Russian elements in the country. Kantor's public response was to declare that 'no Avant-Gardist had ever received such a decoration'. He also received the prize of the Jurzykowski Foundation in New York (1982), the French Légion d'honneur (1985), the Cross of Merit of the German Federal Republic (1989) and the Italian Pirandello Prize (1990). It is to be noted that Kantor did not emigrate or withdraw from public life but continued his work and to tour until the end of martial law in 1983; however, a writer in a Solidarity bulletin referred to him as 'an inert puppet in the hands of the junta'. As Krzysztof Plesniarowicz notes, referring to the support he received from the Ministry of Culture and Art: 'True enough, Kantor's theatre had never received such attention in Warsaw as it did during the martial law period, often regarded as an unfavourable time for art' (Plesniarowicz 2001: 126).

Jan Josef Szczepanski, who was the last president of the Union of Writers before it was banned under martial law, wrote:

> Cricot 2 managed to carve out and maintain a place for itself regardless of the tightening and loosening of communist cultural policy … when it came to Cricot 2 Kantor himself apparently paid no heed to the political context in which he realized his intentions. All he cared about was art. To a significant degree, this immunized his theatre, making it incomprehensible to the ideologues, while at the same time appealing to their snobbism, all the more because its foreign successes endowed it with particular prestige.
>
> (Plesniarowicz 2001: 127)

The next invitation to come to Kantor was from Karl Gerhardt Schmidt, a banker from Nuremburg, who also had a gallery and wanted to commission a theatre piece with some connection with Nuremberg. Kantor immediately thought of the story of Veit Stoss, the

famous sculptor of the altarpiece in Mariacki church in the centre of Krakow, who on return to Nuremberg had been punished for his debts by having a nail driven through his cheek. The outcome was a brilliant piece, *Let the Artists Die*, which combines the story of Veit Stoss with the presence of Marshal Josef Piłsudski, the founder of the Polish legion and Poland's key romantic military hero. Piłsudski as leader is seen through the eyes of young boy who travels in his cart in front of Piłsudski's horse, followed by a band of generals. The piece, more than any of the other Cricot 2 creations, is dependent on the interaction of performer and object, and strikes out in what seems to be a new direction for Kantor, with virtually no story, little text, and a set of startling visual reflections. It was performed in January 1986 on the stage of the Słowacki Theatre in Krakow – a kind of official homecoming and recognition for Cricot 2. The piece, although it was never taken to Britain or the United States, toured to Italy, France, Germany, Spain and Brazil (Buenos Aires) and remains Kantor's last acknowledged masterpiece.

In 1986 Kantor gave a series of workshops at the Piccolo Theatre in Milan, the first time he had presented himself publicly as a teacher. The students were twelve recent graduates of the Milan School of Dramatic Arts. In effect the workshops consisted of a series of lectures complemented by practical exercises, which still surprise today by their audacity. We examine them in detail later in this book. The key concept was that, in order to understand theatre, we must understand art, in particular the abstract, surrealist and constructivist revolutions of the twentieth century. In fact Kantor was answering Peter Brook's 1961 complaint that theatre in the twentieth century had never caught up with the visual arts. These lectures, the only written insight we have into Kantor's working methods and his teaching style, were later published in English as *The Milano Lessons*, as well as in Italian, French and Polish.

Kantor's next production, another installation-type cricotage entitled *The Machine of Love and Death*, was shown at the Kassel Dokumenta 8 exhibition in June 1987. A critic wrote in *Avvenire*:

> the tempestuous and changing images steered by the wisely conceived music of Saro Cosentino … the processions of living-dead specters … the stage governed by organized disorder, in the centre of which stand heavy metal doors that open wide to expel from inside marionette figures, or to reveal three supermarionettes, the royal servants.
>
> (Plesniarowicz 2001: 135)

In spite of the critical acclaim for *The Machine of Love and Death*, Kantor never agreed to further performances as he was beginning to work on his next 'major' piece, to be called *I Shall Never Return*. The first performance took place in Milan in April 1988. When pressed Kantor admitted that the place to which he would never return was, above all, Krakow, 'my beloved city'. The elements of the piece included isolated phrases from his own copy of the 1944 *Return of Odysseus*, with the figure of Madame de la Mort as a key element. *I Shall Never Return* was performed in Germany, the United States, France, Spain, the Netherlands, Portugal, Poland, Japan and Iceland, but the critical reception for once was beginning to be ambiguous.

By now there was a feeling among the Cricot 2 actors that Kantor was in a hurry, and the footage of rehearsals of his last piece, *Today is My Birthday*, prepared in Krakow with his Polish performers, shows a man frustrated and maybe even ill. By now he was living alone in his flat in ulica Sienna. Although he was being looked after by his last companion, Anna Halczak, he is said to have made statements such as 'I am completely alone; I have no one to talk with', 'what an abyss has been created around me', and other such pessimistic pronouncements. A major event that had taken place during Kantor's last years was that the enemy – communism – had suddenly been, if not eradicated, then at least routed: the Berlin Wall had been knocked down in 1989. As one who had grown up and matured during the triumph of communism and its restrictions, and who, in a strange way, had benefited from them, in that his imagistic and overtly dissident work had managed both to bemuse the authorities and to attract an international audience, Kantor could now see the advent of another conqueror of his homeland – the Western market economy – and there may have been a sense in which he could see himself losing his way.

In the summer of 1990 he led another month-long workshop for a multinational group, at the end of which he made what was his final complete theatrical work, *Ô douce nuit* (Silent Night), which was performed only four times in the Chapelle des Pénitants Blancs in Avignon. A film and a commentary were published in France after his death. For now the concentration was on his last unfinished piece, *Today is My Birthday*, the elements of which seem to have been the summation of much of his work – a room full of paintings which harbour figures from the past, a room which is invaded by cages full of historical characters, much music – particularly by Berlioz. In the midst of rehearsals on

7 December 1990 Kantor left, feeling unwell, and he died the following day, Saturday 8 December, aged seventy-five. He was buried in Krakow's prestigious Rakowicki cemetery, his tomb surmounted by his sculpture *Boy at a Desk*. The streets of the city were silent as the hearse wound its way from the Main Square to his final resting place, accompanied by what seemed to be the whole artistic community not just of Krakow but of Warsaw as well.

After his death the Cricot 2 company continued with the production, premiering it in Toulouse and then touring to the United States and to European countries. At the Edinburgh Festival it appeared as part of the official programme, no longer on the Fringe. An empty chair for Kantor was incorporated as part of the show, which ended with an abrupt freeze frame representing Kantor's last created visual image. Thus ended an era of Polish theatre which produced a unique artist, whom we now celebrate – along with Stanislavsky and Grotowski, both of whom he despised, and Meyerhold, whom he adored – as one of the great theatre-makers of the twentieth century.

KEY WRITINGS

INTRODUCTION

Unlike Stanislavsky, Meyerhold, Michael Chekov, Brecht, Lecoq, Artaud and Craig (perhaps his greatest mentor), Kantor did not produce works of theory or practical workbooks. With the exception of *The Milano Lessons*, which we will come to later, he never saw himself as a teacher of theatre, although he had taught visual art on several occasions in his life. It seems as though he never considered that he had pioneered or originated a way of creating theatre which could be passed on, although everyone who saw any of his productions must have thought long and hard about the process used to create them. Although Kantor often used texts by Polish writers, particularly Witkiewicz, Wyspianski, Schulz and Gombrowicz, the spoken word was often only one among a collection of signifiers of the drama, and by no means always the most important. In fact one of the reasons why Kantor's productions were able to speak to so many audiences that did not understand Polish was because the visual clarity of the works conveyed much of their essential meanings.

Kantor has become a key figure in the twentieth-century tradition of making theatre from a collection of sources – textual, aural, visual – which the British have decided to call 'devised theatre', an unfortunate term which has managed to create a division between plays and play-wrights, on the one hand, and multi-textual theatre, on the other. If we

look at the work of some of the major theatre-makers of the twentieth and twenty-first centuries – Brecht, Grotowski, Meyerhold, Mnouchkine, Robert Wilson, Robert Lepage, the Wooster Group, Pina Bausch, DV8 Physical Theatre, Forced Entertainment, to name but a few – we will see that there is indeed a fine historical line of European theatre-making that uses the verbal text as merely one element of the total experience. Kantor sits well among this group in insisting on the primacy of the visual in theatre, and there is a large collection of his drawings, notes and sketches for performances in the Cricoteka archive in Krakow. However, none of this material attempts to show how the elements were put together. There method was known only to the artist, and if we look for elucidation in Kantor's writings we will not find it, apart some significant clues which we will examine in this chapter. In retrospect we can see that Kantor had strong links with visual art/performance movements such as Allan Kaprow's Happenings in the USA, which were seen as 'non-matrixed performances' using various 'found' environments. Kantor's Baltic Sea Happening at Lazy, near Osieki on the Baltic coast, and his various events in Warsaw and Yugoslavia in the 1960s, for example, were associated with these, building also on his earlier admiration for the European Dadaists and their performative activities.

In 1955 Kantor visited Paris, where he came across *art informel*, the categorisation of certain improvisatory art by the French critic Michel Tapié in his book *Un art autre* (1952). Tapié had suggested a category of unstructured art which was aural as well as visual and included types of abstract painting such as Tachisme and Abstract Expressionism. Thus much of Kantor's writing also stems from his visual art roots and the connections he was able to make in Paris with the work of, for example, Jackson Pollock, whom he met. This also perhaps explains why he always felt much of an outsider in the field of traditional theatre performance: he was, after all pioneering approaches other than the dominant model of work with writers, actors and directors, in a direct line with those visual artists who historically had chosen performance as one of their means of direct intervention in social life or politics.

What we do find in Kantor's written legacy is a series of essays, poems and manifestos, all of which attempt to sum up his thoughts and obsessions at different periods of his life. While some of these are fairly impenetrable attempts at theory, more often they are written in a poetic style which is easier to access. All endeavour to justify what Kantor always sees as his intense opposition to the mainstream Polish theatre of his day,

with its playwrights, troupes of actors, theatre buildings and hierarchies. Each of the writings we will consider tries to introduce new concepts of theatre that are always seen as opposing both historical trends and what Kantor saw as the status quo in Polish culture. In spite of much of Kantor's working life coinciding with the influential Polish student theatre movement of the 1960s, which produced a mass of performances in styles which were overtly critical of the regime – companies such as Stu Theatre, Theatre of the Eighth Day, Pleonasmus, and many more – throughout his writings he seems to see himself as a lone figure fighting the orthodoxy of a tradition that had created frameworks in which he could no longer function. Often the essays and manifestos seem to be a cry of despair from an artist in the wilderness, and it is interesting to see the gradual reduction of the despair factor as Kantor becomes aware of the positive critical reaction to his work from a variety of countries.

But first a word about style and form. Many of Kantor's writings are in the form of a manifesto, which can be defined as a public declaration of principles and intentions. It is usually used by political parties, most famously by the communists of the Russian Revolution of 1917, whose manifesto had been written in the British Library in London by the philosopher Karl Marx. But in the early twentieth century the form was also used by artists such as the Dadaists, Surrealists, Constructivists and Futurists as a way of allowing their ideas and pronouncements to be seen as important political statements, and as evidence of their claim for art and culture to be at the centre of political life. As Kantor saw himself directly in the tradition of those avant-garde movements, it was logical that he would use the manifesto form as a way of proclaiming his thoughts. However, in so doing he subverts the form, in that he is not representing a movement, but only himself, so that these writings become a record of his feelings and attitudes over the whole of his life. They are very much the confessions of a frustrated artist, as we shall see, and often read like howls of rage from someone who feels very much alone, so that we must remember that, for most of his working life, Kantor lived in a country controlled by outside forces, and which, at the time of his most famous theatre performances, was under the domination of Russia. It is also true that Kantor's behaviour in rehearsals often paralleled the frustration he expresses in his writings. In the analysis of the writings that follow I have chosen to extract the key concepts as Kantor invented them, so that we can see chronologically how his thinking changed over the years. We can also note the way in which he plays

with the typographical devices of capital letters and spacing, to add emphasis when he wants.

THE *INFORMEL THEATRE* (1961) AND AN UNDATED MANIFESTO

These two manifestos were written in the 1960s at the time that Kantor was presenting Witkiewicz's *The Country House* in Krakow. Poland was by this time firmly under communist domination. There was much cultural censorship and members of the cultural community were reprimanded for maintaining foreign contacts, thus creating conditions in which Kantor must have felt even more alone:

> [The Informel Theatre] is a discovery of an unknown aspect of REALITY or of its elementary state: MATTER that is freed from abiding by the laws of construction, always changing and fluid; that make all attempts to compress it into solid form ridiculous, helpless and vain.
>
> (Kobialka 1993: 51)

The Country House was the performance, in the tradition of *art informel*, where he put the performers into a wardrobe in which they played for half an hour jammed together, talking what Kantor described as 'nonsense'. In the *Informel Theatre* manifesto he describes this:

> The actors are crowded into the absurdly small
> Space of a **wardrobe**;
> They are squeezed in between and mixed with dead objects (sacks, a mass of sacks),
> Degraded, without dignity;
> They are hanging motionless like **clothes**;
> They are identified with the heavy mass of sacks
> (sacks – Emballages rank the lowest in the hierarchy of objects, and as such they easily become o b j e c t l e s s matter).
>
> (Kobialka 1993: 53)

The continuation of the *Informel Theatre* manifesto, given the subtitle of Definitions, goes on to explain the significance of *informel art* in comparison with the Constructivist movement of the Russian art avantgarde, which had opposed naturalism, expressionism, and symbolism as a way of coming to terms with the role of art in Russia at the time of

the revolution. The ideas of Constructivism had also proposed a social revolution and technological developments, but for Kantor this meant a freedom of invention that was the equal of the artist's empty canvas. It is interesting that, although we see Kantor today as the major twentieth-century artist who saw theatre as primarily a visual art, as far back as 1960 the British director Peter Brook had complained in an article in *Encore* that theatre had not caught up with the different movements in painting which had questioned the nature and purpose of art:

> Is there nothing in the revolution that took place in painting fifty years ago that applies to our own crisis today? Do we know where we stand in relation to the real and unreal, the face of life and its hidden streams, the abstract and the concrete, the story and the ritual? What are 'facts' today? Are they *concrete*, like prices and hours of work – or *abstract*, like violence and loneliness? And are we sure that in relation to twentieth century living, the great abstractions – speed, strain, space, frenzy, energy, brutality – aren't more concrete, more immediately likely to affect our lives than the so-called concrete issues? Mustn't we relate this to the actor and the ritual of acting to find the pattern of theatre we need?
> (Hunt and Reeves 1995: 45)

It is interesting that Brook, too, found himself unable to function within the British tradition of theatre-making and eventually removed himself to Paris, where he continued to innovate at his Théâtre des Bouffes du Nord. Kantor would have understood Brook's concerns exactly, though there is no record of the two men ever having met.

In the next section of the manifesto Kantor then goes on to list *Ways of treating matter/physical actions within and without matter*, which provides some clues as to the ways in which he worked with the actors and objects in rehearsal:

COMPRESSION
CRUMBLING,
CRUSHING,
CONTRACTION,
COMMIXTURE,
KNEADING (as one does with dough)
POURING/LEAKING/FLOATING/SWIMMING,
BRANDING
THROWING,
SPLASHING,

DABBLING,
TEARING,
BURNING,
RAVAGING,
ANNIHILATING,
STITCHING,
BLEACHING,
DIRTYING,
SMEARING

'Different kinds of matter' are then listed:

EARTH,
MUD,
CLAY,
DEBRIS,
MILDEW,
ASH,
DOUGH,
WATER,
SMOKE,
FIRE

'Language: The Raw Matter of Speech' is defined as:

INARTICULATE SOUNDS,
MURMUR,
STUTTER,
DRAWL,
WHISPER,
CROAK,
WHINING,
SOBBING,
SCREAMING,
SPITTING,
PHONEMES,
OBSCENE LANGUAGE,
SYNTAX-FREE LANGUAGE

(Kobialka 1993: 57)

Here we can see an approach to the roots of performance which lies in the Surrealist sounds and actions that would be produced by the use of the above methods, or, rather, provocations. It is clear that Kantor, at this point in his career, might be seen to be moving towards a theatre

that seems even closer to the world of Antonin Artaud, the French pioneer of an extreme form of performance designed to affect the audience by extreme behaviour. But this would be dismissed in his next manifesto.

ZERO THEATRE (1963)

By the time this manifesto was written Kantor had toured to Italy, France, Sweden and Germany, exhibiting his paintings; he had written a manifesto on *emballages*, and had designed the sets for two operas, Massenet's *Don Quichotte* in Krakow and Bartók's *Bluebeard's Castle* in Warsaw. At that time the Cold War with the Soviet Union was at its height and censorship had been increased in Poland, with only approved artists being allowed to leave the country. So one continues to wonder at Kantor's travels: he had never become a member of the Communist Party (unlike Grotowski, whose work was seen at regular intervals outside Poland), but nevertheless his art was viewed by the authorities as something worth exposing in the 'West'. In *Zero Theatre* once again we have lists of processes, actions and emotions which are to lead:

> TOWARDS EMPTINESS AND 'ZERO ZONES'
> This process means
> Dismembering logical plot structures,
> Building up scenes, not by textual reference but
> By reference to
> Associations triggered by them,
> Juggling with CHANCE or
> Junk,
> Ridiculously trivial matters,
> Which are embarrassingly shameful,
> Devoid of any meaning
> And consequence

> (Kobialka 1993: 60)

Here we can see Kantor's links with the chance ideas of the American John Cage, expressed in the latter's radical *Theatre Piece* (1960) – although once again there is no record of the two artists ever having met. The lists are more and more reductive and illogical as they continue, deliberately intended to attack any traditional ways of creating theatre:

Slowing of pace,
Loss of rhythm,
Repetition,
Elimination through noise,
Stupidity,
Clichés,
Automatic action,
Terror …
Decomposition of acting;
By acting poorly,
Acting 'on the sly',
Acting 'non-acting'!
These actions
Are accompanied by
Specific mental states –
On the condition that these actions are neither independent of nor
Triggered by these states
These actions are appearances of specific mental states rather than the
Symptom of cause and effect
These mental states are
Isolated, groundless, autonomous
And as such they can be perceived as the factors influencing artistic
Creation
Here are some of them:
Apathy
Melancholy
Exhaustion
Amnesia
Dissociation
Neurosis
Depression
Unresponsiveness.

(Kobialka 1993: 61)

These, according to Kantor, are the states he wishes to achieve in order to counter what he calls 'all this baggage of old meaning and depth'. Here we have echoes of the Dadaist and Futurist movements of the inter-war years, whose followers also wished to get rid of all traditional ways of creating and configuring theatre activities. Instead Kantor wishes to achieve a state of 'non-acting', so that everything that happens on stage becomes a means of turning the actor into an element in a visual construction directed and produced by himself. His plea in this manifesto is for stage performance to

be able to start from zero, where the performers, like oil paints on an artist's canvas, can simply be agents for the artist to use in the creation of art. In this need to oppose all traditional theatre methods in the cause of originality, we see how close he came to the thoughts of Edward Gordon Craig, who also saw the theatre as a canvas on which the artist shaped and reshaped the elements, of which the performer is only one. These ideas were maintained throughout his career, and it is interesting to speculate what might have emerged had Kantor ever met Samuel Beckett, who similarly constructed a series of performance pieces which were essentially based on single visual images – for example, *Not I*, in which a woman's mouth alone is shown spewing out memories; or *Come and Go*, where three women gossip on a wooden bench; or *Ohio Impromptu*, where a lone man at a table, on which lies a black, wide-brimmed hat, seems to be reading a sad story of the past to a silent listener, who prompts by knocking from time to time.

There is film of Kantor preparing his last performance, *Today is My Birthday*, where the rehearsal room contains all the elements of the production – objects, cages, costumes and actors. Kantor creates the piece by moving these elements around, changing their appearance, sound, speed, in the same way as an artist might change elements of colour on a canvas. The performers therefore also need to feel that they are at zero, so that they can become vital elements for Kantor, given life by him and not by some previously agreed form of training or analysis. The titles of sections of this manifesto display his thinking:

> SURREPTITIOUS ACTING
> ERASING
> INTERNALIZATION OF EXPRESSION
> MINIMALIZATION. ECONOMY OF MOVEMENT AND EMOTION
> REDUCTION OF MEANINGS TO THE ZERO STATE
> ELIMINATION BY FORCE
> EMBARRASSING SITUATIONS
> AUTOMATION
> ACTING UNDER DURESS
> EMBALLAGE.

He ends the manifesto by saying:

> A huge, black, 'emballage'
> Is the final and radical
> Tool of complete
> Extermination

<div align="right">(Kobialka 1993:70)</div>

This might indicate that the ultimate death for traditional theatre is to wrap it up! But it is also a metaphor – as we now know – which Kantor uses often in his writings to describe how he saw the elements of memory in his world. It is interesting to note how his theories of the destruction of the actor become replicated in the methods of certain contemporary theatre directors such as Andrejz Zholdak, who also sees the actor as an element to be manipulated like paint on a canvas. And Samuel Beckett's instructions to his performers, particularly in his later pieces, can also be understood as an attempt to control exactly the look and feel of the performance.

The production of Kantor's which came closest to exemplifying the principles of the Zero Theatre was that of Witkiewicz's *The Madman and the Nun* in 1963 in the Krzysztofory Gallery in Krakow. For this Kantor constructed a huge pyramid of joined-up chairs in the form of a mobile, which shuddered and juddered as it was activated. He called it the *Machine of Annihilation*. This machine drowned out the actors' speech and pushed them off the small stage, making it impossible for them to perform. In an interview Kantor said:

> The zero sphere mainly affected what the actors did ... [between the Madman and the Nun] sat two secret policemen, let us call them informers, completely stupid. The Madman said his first line. The Policeman seated next to him looked at him without understanding anything. He thought things over and then passed the information on to the second informer, who in turn distorted the information even more, and passed it on to the Nun. The text was so distorted that its meaning was reduced to zero. When the Nun answered with the correct text from Witkiewicz, she turned it into a completely absurd story.
>
> (Plesniarowicz 2001: 88)

Kantor considered this one of his best productions, and classed it as one of the key moments in achieving artistic autonomy by theatrical as opposed to 'dramatic' means. The production, however, received only twelve performances: it is thought that the image of the annihilation machine had offended the communist authorities, as had also the 'stupid' whispers of the police.

THE THEATRE OF DEATH (1975)

This can be considered the most important of Kantor's writings, composed at the same time as the first performance of *The Dead Class* in

1975, and no doubt influenced by the material of that piece. By the time he wrote it the Cricot 2 company had established a European reputation with two more pieces by Witkiewicz, *The Water-Hen* and *Dainty Shapes and Hairy Apes*, both of which had been shown to great acclaim at the Edinburgh Festival at Richard Demarco's gallery. Demarco by this time had developed a reputation for bringing to Edinburgh new and challenging theatre from outside the UK. The environment for *Dainty Shapes and Hairy Apes* in the Krzysztofory Gallery 'resembled a huge iron cage with hooks and hangers similar to those in a slaughter house, where they are used for pieces of meat' (Kobialka 1993: 301).

The actors were equipped with a range of objects – one was a man with two bicycle wheels in his legs, one had a wooden board on his back, one had two heads, one was carrying doors. These objects, 'grown into' the body, made it impossible for the actors to become traditional characters, while forty members of the audience were playing characters all named Mandelbaum and all dressed in black. A huge mousetrap became a weapon in a duel, at the end of which the hero, Tarquinius Flirtius-Umbilicus, was killed.

In the above descriptions we can see the considerations that motivated Kantor to create a new form of artistic theatre, where the performers were essential elements halfway between living beings and objects, and where their life depended on the means by which the objects were animated. In Michal Kobialka's words these objects, far from being pieces of stage design,

> were spaces that could no longer be located in terms of any external hierarchy of importance or knowledge. It was within the boundaries of such spaces that Kantor presented his experiments. Each of them questioned the traditional idea of representation and interpretation by insisting that theatre be treated as a place producing its own space where the vision of the ever-present artist was executed.
>
> (Kobialka 1993: 304)

In *Dainty Shapes and Hairy Apes* the audience also was trapped, having to enter through a cloakroom space where they were forced to leave their coats:

> Like the coats hanging on hooks, the spectators were either squeezed together or separated by the actors/attendants. The audience's live participation was not, however, limited to those external actions. Because the play was presented

in a cloakroom and the actors shared the space with the audience, the spectators were either asked to play the parts of some of the characters or participated in physical and linguistic exercises. They were forced to abandon the privileged position of an audience, of being seated, and they were forced to assume the function of sharing responsibility with the actors for the events that occurred in the performance space.

(Kobialka 1993: 302)

The work of these two productions, together with his earlier experiments with Happenings in Warsaw and on the Baltic coast, became the experiences from which Kantor then explored the meaning in the *Theatre of Death* manifesto, which is a set of poetic and philosophical reflections on his work leading to his concept of a theatre 'on the other side'. For *The Water-Hen* in 1967 he had converted the Krzysztofory Gallery into a space that looked like a poor house:

The whole space was filled with mattresses, old packets, ladders, wooden partitions, stools, chairs, and so on in such a manner that there was no separation between the audience and the actors. The spectators were under the influence of the same problems and moods as were the actors. A wandering group of travelers with their bags entered the space ... once inside they engaged in banal, everyday actions and gestures so as to define themselves:

1. A man with suitcases looks round the room and says to one of the audience members, 'I must have seen you somewhere'. He begins to run, pulling his suitcases behind him. He stops, arranges the suitcases, rearranges them, counts them etc.
2. Someone demands a cup of tea.
3. A girl with a paper bag full of receipts ... turns around and without any interest in her voice asks, 'What time is it?'
4. A man with a bucket full of water runs across the room.
5. Someone is making a telephone call.
6. The waiters serve the customers.
7. A woman counting teaspoons screams hysterically, 'One spoon is missing', and throws all the spoons on the floor.
8. Someone asks, 'Do you have a problem?'
9. Someone else asks, 'Has it started yet?'
10. Someone pours hot water into a bathtub.

All these activities were mixed with a dramatic text.

(Kobialka 1993: 296)

This idea of the performer either as an object or as carrying an object relates directly to the ideas of the British designer and theatrical pioneer Edward Gordon Craig, to whom Kantor refers at the beginning of the *Theatre of Death* manifesto.

In April 1908 Craig had published his notorious essay 'The Actor and the Uber-Marionette', in which he seemed to suggest that the live actor, because of his tendency to submit to his own emotions and to rely on another's text, is incapable of being an artist and is only an instrument. In this case it would be better to take on the attributes of a marionette, of which Craig had a big collection. Although this theory was largely misunderstood, in that theatre artists thought that Craig wanted to replace the actor with a marionette, the essence of the thinking was naturally attractive to Kantor, who also felt that theatre, as a visual rather than psychologically realist art, needed to find a new way of utilising the live performer, as we have seen from his experiments with the texts by Witkiewicz. In the *Theatre of Death* manifesto Kantor goes on to dissociate himself from Craig:

> I do not share the belief that the MANNEQUIN (or WAX FIGURE) could replace the LIVE ACTOR, as Kleist and Craig wanted. This would be too simple and naïve. I am trying to delineate the motives and intent of this unusual creature which has suddenly appeared in my thoughts and ideas. Its appearance complies with my ever-deepening conviction that it is possible to express *life* in art only through *the absence of life*, through an appeal to DEATH, through APPEARANCES, through EMPTINESS and the lack of a MESSAGE. The MANNEQUIN in my theatre must become a MODEL through which pass a strong sense of DEATH and the conditions of the DEAD. A model for the live ACTOR.
>
> (Kobialka 1993:112)

Having given a personal history of the artistic movements which have de-humanised the actor – abstraction, Constructivism, Dadaism, symbolism – Kantor finally gives, in capital letters, his rediscovered meaning of the relationship between the spectator and the actor:

> IT IS NECESSARY TO RECOVER THE PRIMEVAL FORCE OF THE SHOCK TAKING PLACE AT THE MOMENT WHEN OPPOSITE A MAN (THE VIEWER) THERE STOOD FOR THE FIRST TIME A MAN (THE ACTOR) DECEPTIVELY SIMILAR TO US, YET AT THE SAME TIME INFINITELY FOREIGN, BEYOND AN IMPASSABLE BARRIER.
>
> (Kobialka 1993: 114)

We can see these thoughts in action right from the beginning of *The Dead Class*, even from the title of the piece itself, which indicates that, although the condition of the performers would appear to be dead, yet the schoolroom in which they sit is full of living memory. To begin with, the space which holds the four rows of old school benches is roped off, so that the audience is separated from the performers, the living in front of a barrier which helps delineate the world of the dead. Kantor, in his notes to *The Dead Class*, wrote:

All human states and emotions – suffering, fear, love – were inscribed into [school benches]. School benches would impose order and control on a vibrant and lively human organism. They were like a placenta, by which something new and unexpected would be nourished; something that would venture outside a bench into the black empty space, only to return to it, the way one always returns back [to the] home-womb.

(Kobialka 1993: 318)

Thus the benches in *The Dead Class* become the framework which controls the relationship between the living and the dead and which Kantor uses as the trigger for the reflections of the performers, much in the same way that any static space for learning, be it schoolroom, lecture hall or laboratory, tends to promote thought, concentration and memory. The old schoolroom as a metaphor for delving into the past has therefore become one of the key theatrical images of the twentieth century. In the opening sequence of the piece the old people seated at the benches in their old-fashioned clothes appear as a photograph, frozen in time. But at a gesture from Kantor, who is the link for the audience, the dead people come to life with the famous gesture of the hands asking or answering an unstated question. As the piece proceeds the cast exits at the back of the gallery, only to reappear with dummies of themselves as children on their backs – another stage in the reclamation of memory in conjunction with the dead:

The memory of childhood was turned into a poor and forgotten storage-room where dry and forgotten people, faces, objects, clothes, adventures, emotions and images are thrown. … The desire to bring them back to life is not a sentimental symptom of me getting older, but it is a condition of TOTAL life, which must not only be limited to a narrow passage of the present moment.

(Kobialka 1993: 318)

REALITY OF THE LOWEST RANK (1980)
AND LATER WRITINGS

If sometimes Kantor's thought processes may seem difficult to follow – they are equally difficult in the original Polish – it is now clear that he uses the manifesto form to enunciate new concepts as well as to remind us of recurring ideas, many of which are oppositional strategies to what he sees as traditional theatre practice. The *Theatre of Death* manifesto is particularly difficult unless one reads it as a kind of reflection rather than as a philosophical programme. A better summary of what Kantor means can be found at the end of his manifesto *Reality of the Lowest Rank* of 1980. In this he revisits former ideas of *informel* theatre and the idea of the 'POOR' object, which stems from his underground theatre during the Second World War. He gives short descriptions of objects used in several productions. Here are a selection of some of these:

1. 1944. THE UNDERGROUND THEATRE.

THE RETURN OF ODYSSEUS

1. The ROOM was destroyed by the war activity of 1944
 Odysseus returned to this room rather than to a mythological Ithaca
 The ROOM was not the auditorium,
 The ROOM was not a part of 'stage design'
 The ROOM was a real site which was as real as the events surrounding the audience
 The ROOM was thus an integral part of a work of art: a production
 The audience was inside the work of art.
 It was the first environmental art
 The ROOM-OBJECT
 'POOR' OBJECT
2. The naked and poor WALLS, marked by gun shells, were a substitute for a Greek horizon and its blue and sunny skies
3. A WHEEL smeared with mud,
 A MOULDERED BOARD hanging from the ceiling. A rust-eaten GUN BARREL resting, not on wheels, but on a TRESTLE smeared with mud and cement, DEBRIS, EARTH
 i. Were used instead of a palace interior, marble, columns ...
4. The WAR ANNOUNCEMENT was played through a street loudspeaker, instead of the heroic song of a Homeric bard.
 VII. 1975. THE THEATRE OF DEATH
 1. The mystery of death, a medieval 'dance macabre', is executed in a CLASSROOM

> The decrepit and old-fashioned school BENCHES become the
> ALTAR in this ritual of death.
> 2. A symbol of death is a symbol of life; a CRADLE is a COFFIN.
> Instead of a new born baby, two wooden, dead balls are used. Instead of the
> child's whining, the dry rattle of balls is heard.
> 3. The act of giving birth takes place in a primitive FAMILY MACHINE.
> 4. THE OLD PEOPLE AT THEIR GRAVES, dressed in funeral clothes, rather
> than the noble heroes of Proust's novel, are in search of lost time.
> An extremely important REMARK:
> All these figures, objects, and situations of
> The LOWEST RANK
> Are not a manifestation of a PROGRAMMATIC (PLANNED)
> CYNICISM
> They are shielded from this old-fashioned and easily available idea by
> POETRY AND LYRICISM.
> In the domain of the lowest reality,
> THE ESSENCE OF LIFE, bereft of
> STYLIZATION, GLITTER, false PATHOS, or ACADEMIC
> BEAUTY,
> Is to be found.
>
> (Kobialka 1993: 120)

Many of Kantor's major concerns are expressed in these essays and manifestos, often at repetitive length. Issues of staging, the essence of theatre, space, fiction and reality, all these are returned to time and again as being the key concepts with which Kantor felt he had to grapple. One of the key issues that appears regularly throughout is his concern with the nature of Fiction and Reality. Kantor wanted his theatre to be able to touch the lives of his audiences, to be able to bring a new kind of reality to audiences, a reality which had little to do with the fictionalised reality which he saw being represented on the traditional Polish stage every night. It would seem that one of the reasons why he was so much influenced by the writing of Witkiewicz was that the latter's work was completely at odds with the writing that Kantor felt had dominated the history of theatre. Even a few of the characters in Witkiewicz's play *Tumor Brainiowicz* indicate that we are not to expect any kind of conventional reality on stage:

> TUMOR BRAINIOWICZ – Very famous mathematician of humble origin.
> Forty years old GAMBOLINE, DAUGHTER OF PRINCE BASILIUS – from the
> noble line of the Transcaspian Trunduhl-Bheds.

Primo voto: Countess Roman Kretchborski; *secundo voto*:
Mrs. TUMOR BRAINIOWICZ. Thirty six years old

He is a giant built like a wild ox. Low buffalo brow with a huge head of rumpled blond hair falling down over his face. Magnificently dressed. A red decoration in his buttonhole. Across his shirt front there can be seen the green ribbon of some Eastern order. A gray suit of the best cord and yellow shoes. Clear blue eyes. Close-clipped flaxen moustache. Otherwise clean shaven.

She is a magnificently developed brunette with light down on her upper lip. Fiery black eyes. Somewhat oriental. A wildly exciting thoroughbred.

BALANTINE FERMOR – Spinster. (The Right Honourable Miss Fermor) Daughter of Henry Fermor, Fifth Earl of Ballantyne. Thirty-two years old. Beautiful, majestic blonde; healthy, very exciting thoroughbred.

PROFESSOR ALFRED GREEN – from the M.C.G.O. (The Mathematical Central and General Office). Blond hair, pince-nez. A thoroughly English type. Forty-two years old. Completely clean shaven.

<div align="right">(Witkiewicz 2004: 47)</div>

In his essay 'New Theatrical Space: Where Fiction Appears', written in 1980, Kantor discusses the reasons why he sees that fiction and imagination, in theatrical terms – or rather the fiction and imagination that he admired and wanted to promote – should logically need to look for new kinds of theatrical spaces. Theatres as they had developed had become places which were conditioned by traditional concepts of drama or Fiction – 'neutral, abstract, sterile, uncontaminated by life'. It had therefore become necessary to find spaces in which this new form of fictional reality could take place. Hence we find that Kantor's Cricot 2 theatre pieces were hardly ever played in traditional theatres, nearly always in alternative spaces such as gymnasiums, churches or, more likely, galleries. He wished to dismantle the machinery of theatre and its architecture, which he felt were produced 'only to mislead or cheat a spectator'. For Kantor, a true theatre would give the spectators a new kind of performance by utilising methods that were far removed from naturalistic ideas and that therefore would need to be played in different spaces, much like all the experiments in audience–actor relationship pioneered, for example, by the Constructivists. It became clear from this that Kantor had to invent a new theatrical reality in a new space.

In the case of *The Dead Class* the new space became the roped-off area in which the old desks were placed – not a set design, but an environment which promoted action. In the case of *Wielopole, Wielopole*, the space was a room, the poor room of Kantor's imagination. This was a

concept that appears throughout his writings but is elucidated in his essay 'The Room: Maybe a New Phase 1980'. In this he analyses his use of the room in *Wielopole, Wielopole*, which was produced in that year, and which went on to become the second most famous of all Kantor's theatre pieces:

Here, this is the room of my childhood, with all its inhabitants.
This is the room that I keep reconstructing again and again
And that keeps dying again and again
Its inhabitants are the members of my family
They continuously repeat all their movements and activities
As if they were imprinted on a film negative shown interminably
They will keep repeating those banal,
Elementary, and aimless activities
With the same expression on their faces,
Concentrating on the same gesture,
Until boredom strikes …
There is also a place 'BEHIND THE DOORS',
A place that is somewhere at the back of the ROOM;
A DIFFERENT space;
An open interior of our imagination
That exists in a different dimension
This is where the threats of our memory are woven,
Where our freedom is born …
At the same time, the ROOM cannot be 'furnished', cannot be the place beyond which the auditorium begins, cannot be the stage. If it were the room would be nothing more than a scene design, which would irrevocably rush our hopes for achieving realness …
We will have to accept memory as the only realness. This means that we will have to build a rational model of memory and define its sphere of activities as well as means of expression …

(Kobialka 1993: 142)

Kantor expects us to see this in action during the process of *Wielopole, Wielopole*, where the family plays out its repetitive movements in the space designated as the room of his imagination. The space at the back, through the door, is where the historical actions which give rise to the actions of Kantor's memory take place.

Towards the end of his life Kantor wrote a series of essays which appear to be summing up for himself his achievements and reviewing the results. 'The Real I' (1988) states that:

Everything I have done in art so far
Has been a reflection of my attitude
Towards the events
That surrounded me,
Towards the situation
In which I lived;
The reflection of my fears;
Of my faith in this and not in something else;
Of my distrust in what was to be trusted:
Of my skepticism;
Of my hope.

(Kobialka 1993: 161)

He writes in particular for the first time about his feelings towards audiences and his innate pessimism, which was often harshly expressed in the famous tantrums in rehearsals where he subjected the performers to insults and lost temper. However, it would seem that they had accepted this as the consequence of working with a genius:

I have all I need
The indifference,
Derision, and
Malice
Of the world
I give to … The actors
Those miserable characters of the past.
They will do it better
And more pointedly
To make public
What in the life of an individual
Has been the most intimate,
And what contains
The highest value,
What to the 'world'
Seems to be
Ridiculous,
Something small,
'poverty'
Art brings this 'poverty'
Into daylight
Let it grow
And let it reign
This is the role of Art.

(Kobialka 1993: 165)

END NOTES

In 1990 Kantor presented, with a group of young artists in Avignon, what was to be his last complete theatre piece, entitled *Ô douce nuit* (Silent Night), which was performed only four times in the Chapelle des Penitents Blancs. Afterwards he wrote something which is a cross between an essay, a poem, a confession and an account of some of the ideas of the piece:

Now then, here, on this stage,
The end of the world,
After a disaster,
A heap of dead bodies (there were many of them)
And a heap of broken Objects – this is all that is left.
Then –
According to the principles of my theatre –
The dead 'come alive'
And play their parts
As if nothing happened.
There is more.
The figures,
Which begin their lives again,
Do not have any recollection of the past.
Their attempts at putting
The memory shreds together
Are futile and desperate.
So are their attempts at putting
The objects together.
They try to put them correctly
Together,
To decipher their functions.
A bed, a chair, a table, a window, doors,
And those that are more complex,
A cross, gallows,
And, finally the tools of war

(Kobialka 1993: 174)

The piece is described by Michal Kobialka as marking a shift in Kantor's work and also as redefining the notions of memory and myth or history. This is an account of Kantor's treatment of the Crucifixion, which formed a part of *Ô douce duit*:

Here on stage, at one moment, the doors opened and a procession, led by a man carrying a wooden cross on his shoulders, entered. Among those who walked in the procession were the figures from the opening sequence. The stage became Golgotha. The procession stopped. Nino (stage character in black, holding a cello) watched how the cross was erected. He looked around for a person who could play the part of the 'Crucified One'. A factotum, named Carmelo, advised him. First, Nino pointed a finger at a poor seminary student. The student was placed against the cross. Carmelo was not however fully satisfied with the choice. He suggested a new person. This time a Hassidic Jew was chosen to play the part. He perfectly fitted the Cross. A single shot ruptured the solemn tones of the requiem. All hurried away from the stage. A man in black brought in a wooden coffin/box. The priest, who followed him, ordered the body to be put in it. The Emballage, rather than the crucified Hassidic Jew, was put in the box and carried away. The crucified Hassidic Jew remained alone on stage. After some time he got down from the Cross and sat silently on a chair at the doors. Helka, Nino, and Carmelo entered the 'room' and greeted him. They all seemed to be bored, as if waiting for something to happen. Suddenly from behind the doors, voices singing a revolutionary 'Caira' indicated that the time has lapsed and that it is 1789 now.

(Kobialka 2000: 45)

The piece continues with a section set at the time of the French Revolution.

The last essay by Kantor published in Kobialka's collection is entitled 'From the beginning in . . . My credo was 1990'. It was written during the rehearsal period for *Today is My Birthday*, his final piece which, if the rehearsal films are anything to go by, caused him some distress, since by that time he was already ill. The essay resembles a summing up of his life with, as always, various swipes at officialdom and the way in which art had been sidestepped by the official theatres and also by:

Those theatre groups
Mushrooming all over the last few decades
That exploited the great 'discoveries'
Of surrealism and the Happening
In a superficial manner, for mere effect,
Without any commitment to the ideas
Or Knowledge about them.

He reasserts his belief in being outside the system – 'I was often accused of lacking patriotism in my own country' – and ends the tirade against authority with a deeply moving section on freedom:

Freedom in art
Is a gift neither from
The politicians
Nor from the authorities
Freedom is not bestowed
On art by the authorities
Freedom exists inside us.
We have to fight for freedom
Within ourselves
In our most intimate interior,
In our solitude,
In our suffering
It is the most delicate domain,
The domain of soul and spirit
This the reason I am
Suspicious about those theatres,
And artistic activities in general,
That have emerged recently
During the 'dictatorship of the proletariat'
With (a priori) programs
For the fight for political freedom,
For religious freedom,
For patriotism
The situation was worsened when
Avant-gardish ideologies
Were also mixed into these programs.

(Kobialka 1993: 204)

Not long after this was written the Berlin Wall, erected by the German Democratic Republic to prevent its citizens defecting to the West, was pulled down and communism collapsed in Europe.

INTERVIEWS

There is, however, one other source for Kantor's ideas – in the set of interviews and conversations he had over several years with Krzysztof Miklaszewski, who was close to Kantor over a period of years and was one of the longest-standing performers of Cricot 2. He played, among others, the Beadle in *The Dead Class*, who sings the Austrian national anthem from time to time. The interviews were published in 2002, allowing us to extract Kantor's views on a variety of matters away from

the more public format of the manifesto. I have therefore extracted from these a set of statements which seem to me to relate to some of the key areas examined in this book.

SPACE

In this speech, which he made at a rehearsal of Witkiewicz's *Lovelies and Dowdies*, Kantor expresses his view of the stage as a space which is like an artist's canvas, thereby clearly making parallels between his theatre and the construction of a painting:

> In the ordinary, institutional theatre the stage constitutes an incredibly solid foundation. It serves the actors as a place to act, to present, to imitate. The stage is where the actor acquires the status of artist, as well as praise and fame, often without even trying, without having earned it. Regardless of what shape it takes – Italian style, in the round – regardless of what participational model it tries to lay on the audience, the stage remains at all times a passive sanctuary. Canvas serves the painter as the same sort of sanctuary. In the sanctuary of the stage and the sanctuary of the canvas, all things are possible in contemporary art. Here the greatest excesses are enacted, without any retribution.

> In the Cricot 2 theatre, in more or less all my productions, I keep coming back to the problem of the imperative need to destroy this artistic space, to exit from the reservation labelled 'art'. When art decides to leave its reservation and go out into the world, there comes a moment of protracted collision, because art has its own categories, which are not the same as those of life. The happening, all the 'activité' and manifestos arising from it, were designed to make art leave its reservation and enter the domain of reality. But if I give up on the artistic space constituted by the stage, what have I got left?

> (Miklaszewski 2002: 73)

PROCESS

In this extract from a long interview with Miklaszewski in 1983, Kantor explains his process of creation with the Cricot 2 actors, where the activity has clear parallels with the artist building up a composition on a canvas, and where any text he may use is but one element in the composition – in this case the last one – with several possible stages or versions of completed pieces:

> We focus less on the 'presentation' of a theatrical work of art than on the shaping of our own material and the structure of a theatrical work of art than on the shaping of our own material and the structure of our theatre, so that working in

a new situation and a new aesthetic, concepts like 'premiere' and 'repertoire' have lost their meaning. As far as these 'results' of theatre work are concerned, we should speak rather about the different 'stages' which have been defined by these results … I search with my group for a new form and content of expression, focusing always on the imperative of spontaneity, the sine qua non of all creative work. At first this takes only the most shadowy of forms, more like the negation of the status quo or a premonition. This is slow work, leading to ever more explicit situations, bringing to consciousness new content, the recognition and mastery of new laws and principles of action. All this is work in its own right, unrelated to any kind of theatre art. And only when this independent 'scenic' dimension is strong enough and has bonded with other structures do we introduce the text.

(Miklaszcewski 2002: 101)

CRICOT 2 ACTORS

In the same interview from 1983, Kantor describes the kinds of actors who constituted Cricot 2 in terms of their ideological and, by extension, their political views. This becomes a clear statement of the situation of the company right through the communist period, as being on the fringe, of the 'lowest rank', for the authorities and being relegated by the art officials of the government for many years. This was a condition of life for artists under communism unless they made some kind of agreement with the state to produce acceptable art. Part of Kantor's success lay in his constant struggle against the authorities and their view of art, and his achievements in gaining international approval for art which was going against the official grain back home in Poland. This statement sums up both Kantor's frustration and his framework of success:

What brought them was their desire to collaborate on my idea of the artistic journey, and their distrust of officialdom. This distrust is fully justified, although it can also lead them to sanction institutions and authorities which often turn out to be false. Officialdom has to rely upon the apparatus of authority, and that is its nature. And its weakness. Officialdom cannot allow itself to approve of any developments which threaten it, or which in the language of officialdom are discretely labeled 'controversial'. Officialdom has to rely upon the unshakeable seriousness and dignity of its representatives: directors, presidents, secretaries, dozents, and professors. Sustained by seriousness, the apparatus of officialdom functions splendidly, but in art this produces terrible consequences. There are official theatres, official galleries, official painters, official critics: and the worst are official works of art. There are even official dissidents, who come out with their dissident proclamations, but remain in their art uncommitted and conformist.

(Miklaszcewski 2002: 107)

Kantor's writings are little known and the translations of a selection of his manifestos by Michal Kobialka were published only after the artist's death, in 1993. The interviews and conversations with Krzysztof Miklaszewski were not translated until 2002 by George Hyde, so that students and practitioners have until recently had little to go on which would give an insight into Kantor's thinking. This mostly reflects what Kantor always thought of the cultural establishment, namely that the idea of 'theatre' was often limited to the model which consists of a theatre building, actors, a director, a designer, a writer – a model which still seems to dominate in the UK at least. Many of his writings try and undermine this, often in a style which expresses his immense frustration at being misunderstood while at the same time insisting on the visual importance of theatre. As an artist using a collection of elements, only one of which was the performers, to create a theatrical composition, it was important to keep stressing his ideology of confrontation and dissidence.

The political context of Poland and its reluctant communism imposed at Yalta in 1945 by the agreement of Churchill, Truman and Stalin is also something that always impacts on Kantor's writing, although he never produced political analysis. However, any progressive artist working in any of the communist countries of Eastern Europe, where 'socialist realism' became the mantra for expression, would have had to come to terms with the regime. Much of Kantor's writing has this framework as its context, where his often misunderstood 'experimental theatre' turned out to attract audiences hungry for alternative visions. The interviews in particular reflect the day-to-day tensions of working under these conditions. Where we might have expected such a major artist to have developed a body of theory, like Stanislavsky, Meyerhold or Brecht, we find we have only Kantor's repeated calls for adventure or innovation and a series of howls of rage at not being understood. Perhaps this is one reason why his work remains ill-understood and why when, in the next chapter, we attempt to examine his processes, the evidence is somewhat thin.

The Cricoteka in Krakow may eventually publish a collected edition of Kantor's writings, but these will initially be in Polish only, whereas the paradox is that many of Kantor's greatest admirers and followers are outside Poland. It is, however, thanks to Kantor's own insistence on archiving his own work by means of film and photography that the more

or less complete collection of his productions may be studied in the Cricoteka, which holds the original manuscripts of statements and manifestos. What I have attempted in this chapter is to give a flavour of the thinking of the artist set against his sense of frustration, while at the same time recognising that, even while he was creating the work, he knew that it was indeed something special and unique in the history of twentieth-century theatre-making.

KEY PERFORMANCES

INTRODUCTION

We are extremely fortunate that Tadeusz Kantor insisted on document-
ing his productions with a view to creating an archive of his work, which
eventually became the Cricoteka, the collection housed at various loca-
tions in the city of Krakow. This insistence came from his major preoc-
cupation in his later years, that of the function of memory. In archiving
his theatre work on film, he was aware that only a partial record would
be left, but his obsession gives us a privileged way of seeing the shape and
hearing the sound of his productions. In this chapter we will examine
four of Kantor's key theatre pieces created between 1975 and 1989 – *The
Dead Class* (1975), *Wielopole,Wielopole* (1980), *Let the Artists Die* (1986)
and *I Shall Never Return* (1989). These were the works by which he
became internationally known, and which toured the world, winning
numerous awards and prizes. A performance of *The Dead Class* was
filmed in the Krzysztofory gallery in Krakow in 1976 by the great Polish
film-maker Andrejz Wajda, thus providing the format in which most
people can see the piece today. There are several film versions available
for consultation in the Cricoteka of *Wielopole, Wielopole*, *Let the Artists Die*
and *I Shall Never Return*, the most readily available of which are those by
Andrejz Sapia. His film of *Wielopole,Wielopole*, was made in Wielopole
itself in 1985 and published for the Krakow 2000 festival.

There are filmed versions of several works available in the Cricoteka, which means that we are able to undertake a detailed analysis of these key productions in a way that few other twentieth-century theatre practitioners have enabled us to do. Brecht tried to archive his own work, but his means in the 1950s were limited to photographs, his model books, and a few filmed versions of performances by the Berliner Ensemble, his own company established after the Second World War in what was then the German Democratic Republic. Jerzy Grotowski left us only a few shadowy film versions of his work, together with some interviews. Choreographers have often been meticulous in their documentation for revival purposes, having evolved notation systems which enable us to reconstruct performances. Pina Bausch authorised several videos and DVDs of her work, whereas Robert Wilson has been very selective in what he has allowed to be available on video and DVD to the public. In the light of this, Kantor's own insistence on documenting his work thoroughly has given us unique insight into their shape.

All Kantor's major theatre pieces are concerned with memory and its attempted reconstruction. In the case of *The Dead Class* the memory is of school years, where the stage area divides the living audience from the representations by the company of the dead. In Kantor's idea of a Theatre of Death, the concern is that of resurrecting memory. Krzysztof Plesniarowicz insists that:

> The fundamental characteristic … is the obsessive demonstration by the Cricot 2 actors that it is impossible to resurrect the dead pre-existence of the performance, or bring characters who once existed in history of literature, together with their experiences, back to life.
>
> (Plesniarowicz 2001: 186)

Hence in *The Dead Class* characters are often given physical links with objects, emphasising the connection between the living and the dead, combining some object or place with a human characteristic: the Old Man with a Bicycle, the Woman Behind the Window, the Woman with the Mechanical Cradle, the Old Man in the WC, the Absent-Minded Old Man from the First Row (of school benches), all have obsessive behavioural traits associated with their respective objects. In *Wielopole, Wielopole*, each character brings a gestural characteristic associated with the remembered personality: Mad Auntie Manka, the Little Jewish Rabbi, the Uncles, Marian Kantor the father on leave, the platoon of

soldiers, Uncle Stasio the Deportee with the violin. These gestural keys give us memory clues in recalling the performances, and the filmed versions can therefore act as memory triggers in a way that no other twentieth-century theatre-maker has allowed.

THE DEAD CLASS (1975)

Although Kantor had been creating theatre work either as a designer or director for many years, most of this had been related to single Polish texts of various kinds, in particular texts by Wyspianski and Witkiewicz (known as Witkacy), and so could be seen as being broadly interpretive in nature, albeit in a thoroughly expressionist and surrealist manner. Kantor said of Witkacy in 1956: 'The name of Ignacy Witkiewicz acts on people with a developed sense of humour like a red flag to a bull. And that red flag is what we're after' (Plesniarowicz 2001: 175). Kantor had presented *The Water-Hen* and *Dainty Shapes and Hairy Apes*, both by Witkacy, at the Edinburgh Festival in 1972 and 1973, under the auspices of Richard Demarco, to great acclaim. At the same time throughout his life he had been continuing to draw and paint wherever he went, picking up and presenting strange, often Surrealist images that surprise even now in their conjunctions and collusions of figure and form. However, nothing had prepared the world for the astonishing series of textual and imagistic conjunctions that made *The Dead Class* of 15 November 1975 into one of the key theatrical works of the twentieth century. It was first performed, where much of Kantor's work originated, in the medieval Krzysztofory Gallery in the basement of the sixteenth-century Krzysztofory Palace in ulica Szcepanska in Krakow, which is still very much as it was in Kantor's day. Away from the crowds in the city streets above, *The Dead Class* became Kantor's first great international signature work, eclipsing to a great extent both his former visual work and his former theatre pieces.

The piece – it is not a 'play' by any stretch of the imagination (although most British commentators used this term) – is a collage of texts and images from a variety of 'alternative' Polish writers, with other material and imagery added by Kantor himself. The overall framework is a nineteenth-century schoolroom, with wooden desks, inhabited by twelve performers who present an image of a class of old people, accompanied for some of the time by what appear to be their former selves in the form of mannequins strapped to their backs: ageing school

kids carrying their histories with them. Their 'teacher' would appear to be Kantor, but this is not actually the case. He stands in front of and among them, dressed in black trousers, jacket and scarf and a white shirt, and silently directs them with hand gestures throughout the show. He appears as the master of ceremonies, allowing certain actions to happen and controlling others, while orchestrating the movement and the sound with impatient gestures to the theatre technicians. There is a clear parallel between him and the conductor of a symphony orchestra, who makes sure that the players come in on time. But there is also a kind of Brechtian distance created whereby the audience sees the show partly through the presence of Kantor, who becomes the editor of what we see. The visual impression is of a forgotten or excavated school class of around 1914/15, or so the costumes would imply – an image which connected with audiences everywhere in the world when the piece toured from 1975 until 1990. It also represents visually the time around Kantor's birth in 1915 in a small country town in Poland (or Galicia, as it was then). Inside this framework is played out a multiple texture of image and word in what can only be described as a series of expressionist games, fights and scenes that together combine to make a remembered and distorted picture of school days and memories.

All this is filtered through the mind of Kantor and three key Polish Surrealist writers – Bruno Schulz, Witold Gombrowicz and Stanislaw Witkiewicz, the first two of whom in their different contexts also present the idea of the remembered schoolroom. But the overall image is also importantly of a Polish past which evoked for audiences in 1975, living under a communist regime which was censoring dissident artistic work, a symbol of creative freedom. The fact that Kantor's work was being performed away from 'official' theatres such as the famous Stary Theatre in Krakow, which was only 100 yards from the Krzysztofory Gallery, and that it was difficult to pick up any anti-communist message from the anarchic Surrealist images, meant that audiences were able, in the small basement space, to feel a Polish historical presence that was a world away from the communist life on the streets above. Yet it was a Polish presence that played with itself and the audience in such a way that Kantor described *The Dead Class* as a '*séance*' – a kind of evocation of a Polish past which yet was in no way realistic. In 1975 Poland was in any case, under the premiership of Edward Gierek, going through the very beginnings of a disgust with communism and its rules and regulations, and the first open public protests were taking place. *The*

Dead Class therefore became both a reminder of the past and a symbol of the free creative mind and its ingenuity. And for international audiences, most of whom who did not, of course, understand the Polish texts, the show became an example of Polish performance that was liberating and quite unlike anything previously seen in Europe, even though some audiences would have been familiar with the visual and aural shock of the work of Grotowski from his many tours. However Kantor's performances had little, if any, connections with the more ritualised work of the Theatre Laboratory.

Inside a roped-off area in the basement Krzysztofory Gallery – this is no 'theatre' but a kind of invented performance space – there are four rows of wooden, almost black, school desks that look as if they have been found on an abandoned site, forming what Kantor called 'the wreck'. To the side of the desks is the village 'privy' – the loo 'where one got one's first taste of freedom' – also constructed, like all Kantor's objects, of found wooden boards. Beside the desks, sitting on a chair, there is a dummy with a waxen face, dressed in black. This is the Beadle, a kind of parish councillor, looking like something out of the world of Charles Dickens. At several points in the piece this dummy is replaced by a live actor (Krzysztof Miklaszcewski), who sings the Austro-Hungarian anthem as an attempted counterpoint to the chaos of the 'old' children. There are three lights hanging over the desks, and the overall colours are black and grey – there are no lighting changes throughout the piece. The general impression is of a forgotten small town schoolroom with books about to crumble to dust, a place whose real existence – if it ever actually existed – is in any case something from an invented past. Another description is that it appears, described by Jan Klossowicz, 'like an unknown drawing by Bruno Schulz' (Drozdowski 1979: 109).

As the audience enters the seating area Kantor is standing near the desks, waiting to start the piece, like the classical conductor waiting for the audience to be quiet and the orchestra to start playing. Indeed Kantor's function throughout is the theatrical equivalent of such a figure, constantly guiding the players, making sure the visual and aural balance is correct and as it ought to be. Sitting among the desks are the twelve performers of Cricot 2, all dressed in what might be classed as funeral clothes, with bowler hats and white and grey faces, staring straight ahead in silence, a frozen image of a remembered or invented past. In fact Kantor captured the image after looking through the

window of an abandoned schoolroom that he came across near the Baltic coast.

At a sign from Kantor the show begins, and the twelve performers each slowly raise their right hands with the first two fingers up in the pose of either wanting to ask a question or wanting to show that they know the answer – an archetypal image of an old school where facts and the remembrance of material is of crucial importance. The image of these questioning old people in black behind their poor and old school desks has now become, as we have seen, one of the key theatrical images of the twentieth century.

At another sign from Kantor the old people jump up from their desks and quickly disappear into the dark space at the back of the gallery. Only one performer, the Absent-Minded Old Man from the First Row, remains in the empty schoolroom. In a moment another of the performers comes back, collects him, and drags him away from the room. Suddenly all the old people appear in the entrance, this time carrying on their backs dummies of themselves in black school uniforms with white children's faces. The idea of the dummies, or mannequins, may well have come from Kantor's admiration for the British designer/ director Edward Gordon Craig, who, in his *On the Art of the Theatre*, proposed that the theatre needed to move beyond the natural, that the actor needed to lose his personality and take on the attributes of a puppet in order to release a different kind of imaginative potential. In *The Dead Class* these puppets are both self-images and a kind of homage to Craig, lifeless yet redolent of a life past.

The old people and their dummies are accompanied by the striking sound of the *Waltz François*, composed by Adam Karasinki in 1907 and played on a disc by a ballroom orchestra. This waltz, with its aristocratic overtones of ballrooms and elegant pre-war dresses, becomes one of the key sounds of the piece and is heard from time to time at the order of Kantor. At its first hearing now it accompanies the Grand Parade of the old people circling round the desks with jerky, clumsy movements, dummies on their backs. One character whips the floor as she moves, another – the Old Man with a Bicycle – has his likeness strapped to the saddle of a penny-farthing, yet another – the Old Man with his Double – carries his own image as though dead. They circle 'the wreck' three times then sit down in silence. The music stops, and what follows appears to be the memory of a lesson about Solomon and King David consisting of random associations of words resembling a Dada poem:

> What do we know about King Solomon? (repeated)
> King Solomon …
> Loved …
> Who did King Solomon love?
> Many …
> Strange women
> What women were they?
> The moa … bites

Two old men drag another – the Old Man in the WC – to the loo, pulling his trousers down. He bares his backside while the questions and answers come in quick succession, contributing to the general confusion. They shout:

> Ammo … nites
> Edo …mites
> Hit … tites
> Zidonians,
> Ammonites, Zidonians, Edomites, Moabites

Then comes the next question:

> King David …
> What did King David do?
> King David …
> Oompah, oompah
> Shit
> On your pa,
> King David's grown old
> David's crown
> Absolom cursed David!!!
> Where is the Ark, where is the Ark?

And so on. There is general confusion, and then the performers shout out the Hebrew alphabet. The impression is of another universal memory of unruly children who can't agree on anything. It becomes like a Dadaist chant, the old people accompanying themselves by pulling grotesque faces, watched by Kantor, carrying one of the dummies in his arms. Gradually the image of a wailing Jewish crowd comes to the fore, but the strains of the waltz now seem to calm them down, and they sit quietly, smiling serenely, as if the waltz represents some kind of

paradise or escape from their trapped situation. Now Kantor's imagery, by a strange coincidence, seems to bear a resemblance to some of the images of Samuel Beckett's characters, trapped by past situations from which they cannot escape.

At this point in the film made by Andrejz Wajda in 1976, the characters move outside the gallery for no apparent reason, where one of the characters, the Somnambulist Prostitute, bares her breast while the Old man with a Bicycle trots around what looks like the backstage area of a theatre. There was some confusion over this passage, which was Wajda's attempt, one assumes, to introduce an element of the film-maker's interpretive art and to give the filmed performance some extra dimension. Kantor apparently disliked this interpolation, as did most of the company, but by some means the section has always remained in the documentation, as this performance was generally felt to be of one of the best given of *The Dead Class*. The old people end this part by running around on the hills outside Krakow, and when the piece resumes in the gallery the performers start on more questions and sayings remembered from history lessons:

> What year was Capet's head ...?
> What year was Capet's head ...?
> Queen Anne is dead!!!
> And the geese which saved the Capitol?
> And the geese which saved the Capitol?
> Hannibal ante portas!!!
> THE IDES OF MARCH

And so on, with more chaos and the shouting of Polish and Latin quotations, as if life itself consists of having to say and remember phrases, facts and questions, which are the only things that legitimise existence or keep total anarchy at bay. One of the women keeps walking round, cackling and looking through the wooden window frame which she carries. At a sign from Kantor they all return to their desks, sitting down in silence. Then one of the men gets up and starts giving a lesson on the way the mouth creates sound:

> Various things happen in the mouth when you speak. Lips take different Positions to articulate A or E, and quite different ones for U!!! For B or P, they come together to completely close the air channel, and this is followed by a sudden release resulting in an audible explosion.

Gradually his speech becomes incoherent, and the old people begin fidgeting, starting to test out their own mouths with a vocal composition as follows, which resembles nothing so much as a poem by the Dadaist poet Kurt Schwitters:

Vyst rr bzirk FUMTSEKAKA
Vyst rr bzirk FUMTSEKAKA
Bistri virk FUM TSE KAKA

Kantor conducts this as if it were being rehearsed for a special performance. Then they start making faces at each other, puffing out their cheeks, pushing out their tongues, turning up their noses with their fingers. This is a direct quotation from the novel *Ferdydurke* by Witold Gombrowicz, where there is a challenge of an all-out duel of face-making in Mr Piorkowski's Surrealist school. The turmoil continues, and Kantor chases the performers out of the space; the Beadle's dummy is taken away, to be replaced by an actor, leaving only the dummies in the school seats. Then at last the Cleaning Woman gets up from the corner in which she has been sitting throughout the performance. She is a big woman, played by a man wearing a black dress and a black hat. She begins cleaning up by throwing the decaying books around, thus furthering the atmosphere of disintegration in the room. She finally goes up to the Beadle, takes his newspaper from him, and starts reading from what appear to be an account of the events of 1914, the year before Kantor's birth:

Konstanty Wisniweski, the chemist, recommends tablets
Of his own prescription
Cheap meals for the unemployed
In the streets of Sarajevo, the capital of Bosnia,
A Serbian named Gavrilo Princep
Has assassinated the Crown Prince,
The Archduke Francis Ferdinand and his wife
Kaiser Wilhelm II has ordered a general mobilization
Of the German Empire ...
Well, there's going to be a war ...

The Beadle jumps up from his chair, stands to attention, salutes and sings the Austro-Hungarian national anthem in a wavering tone of voice:

Gott erhalte
Gott beschutze
Unsern Kaiser, unser Land.

These are the first insertions into the piece of what might be termed a version of historical reality, placing the framework of *The Dead Class* firmly at the time of the First World War, a time when German and Austrian control of Poland was unchallenged. So this class of the dead represents an image of controlled humanity, a world that would have been recognised by the audience of 1975 – a Poland under foreign domination, yet where the chemist continues to sell his own recommended tablets. On the other hand, the newspaper and its contents might well have been made up by Kantor, so that we are still in the world of ambiguity. What is genuine are the historical facts quoted and the sound of the anthem.

At this point we may recap what we have watched so far and see the seated old people, the schoolroom chaos, the reading of the newspaper, the singing of the anthem, even the parade of the performers around the desks, as static images or even photographs brought to life, or as drawings by Kantor which form the scenario much more than the textual content. If we try to make sense of the words alone, or, worse, make the mistake of thinking that the words are the major signifier of the piece, we are forgetting that Kantor was first and foremost a visual artist. The words he chooses from the three authors are used like objects or other visual elements – they become tools by which to help construct the totality of the piece. *The Dead Class* is a visual and aural totality of which the only coherent progression lies in the succession of images, which consist of the comings and goings of the group and the moments of silence, with the sounds of the old people as counterpoint, all bound together by Kantor's persistent use of the strange Polish waltz. It is also bound by the way in which the class of old people walk, talk and physically portray themselves as younger versions. Much of the text is shouted at screaming pitch, as if the performers were children attempting to be heard or craving attention, so that the piece often takes on the nature of an expressionist painting, where distorted features are complemented by cacophonous sonic elements. There are clear parallels with Edvard Munch's famous painting *The Scream*.

The next section consists of some members of the group bringing on something that looks like a cross between a gynaecologist's couch and an instrument of torture. This is accompanied by snatches of dialogue

from Witkiewicz's play *Tumor Brainiowicz*. At the same time the Charwoman brings on the Mechanical Cradle, consisting of a wooden box, inside which are two wooden balls which clack and clatter as the box is moved. These are both major examples of Kantor's creation of objects having an invented life of their own, which are then inserted into the already destroyed life of the schoolroom – both objects representing Kantor's theory of Theatre of Death, which we have discussed earlier. The presence of these two instruments of torture simply adds to the unpredictability of the action. The Charwoman now enters holding an object which seems to be a combination of a broom, a scythe and a mop, which she sweeps around the room with wide gestures, just missing the performers and causing everyone to fall on the floor in heaps. With every sweep of the broom the old people collapse. Then there begins a series of textual extracts from *Tumor Brainiowicz*, which are random lines spoken by Witkiewicz's characters in his play, but here are heard as snatches of unconnected sentences:

> Papa writes poems you know … Recite one for us, Iza
> Once there was a little kitten, once there was a soft green mitten
> Ate its breakfast in the by and byes
> Someone gave a secret glance, someone gave a shove by chance
> They all cried out their eyes

At the back of the class one of the men takes on the role of teacher, pointing his finger and provoking a further series of variations:

> Prometheus …
> Prometheus and his liver
> Cleopatra …
> Cleopatra's nose
> The nose, the foot …
> Achilles' heel, Adam's rib, and what about the ear, or the finger, or the eye …

One actor then bares his heel, which is gnawed at by one of the others. The chaos continues, snatches of dialogue being played with and thrown around among the performers like children playing with new words, only all the snatches are related to classic European figures or biblical concepts, such as the camel passing through the eye of the needle, these ideas contrasting previous Jewish elements such as the alphabet. The overall impression is of total confusion of meanings and sounds, and of

what might be termed the futility of memory. At the height of the confusion the waltz arrives again, calming the old people down as a moment of peace and organisation in this world of madness. As the music swells the old people stand to attention, emphasising the controlling nature of this music. After more snatches from Witkiewicz, the Woman Behind the Window interrupts with this speech from *Tumor Brainiowicz*:

> You, children, go for a stroll. It's a glorious day
> Today, Spring is definitely in the air
> The trees are sprouting green all over.
> I've even seen two brimstone butterflies which
> Left their chrysalises encouraged by the warmth and circled
> In the scented air. The poor things, they don't know
> That there are no flowers yet and they'll starve to death

This is the only overtly 'poetic' moment in the piece, at which point the old people hitch their satchels to their backs and leave the space. Wajda's film now takes them outside once again, this time up on the hills above Krakow, where they run around, watched by the silent dummies at the desks which have been placed in the swaying grass – a moment of enjoyment and optimism in an otherwise dark piece of theatre. But they have run 'until they are absolutely exhausted and dead-tired', and they stagger back to their desks in the gallery space.

There follows an extended section using elements from Witkiewicz, which begins with a parody of an erotic scene where the performer Maria Stangret (later to become Kantor's second wife) is kissed by her two male schoolmates. The Charwoman drags various cast members off, while Kantor is picking up the various books strewn around the floor. At this point the whole cast re-enters, each carrying a handkerchief and a notebook. They seem to be in mourning for someone, or perhaps in mourning for their lost personalities. There is a cemetery conversation between them, with snatches such as:

> Not so long ago
> Grass hasn't had time to grow …
> Death cut her down …
> She didn't survive the winter …
> He was always wont to joke …
> But she had nice weather …

Then they begin a long recital of names of the dead, supposedly culled from a real Krakow graveyard by Kantor himself, while one of the cast brings in a pile of black-bordered death posters for each of the old people to hold bearing the name 'JozefWgrzdagiel'. The name itself seems a composite of German, Polish and Jewishness, perhaps symbolising the cultural mixture of Poland at the time of the First World War, perhaps an attempt to show us the ethnic mix of these dead people from the dead class. The only one not to read out the names is the Beadle, who is clearly from the controlling Austro-Hungarian Empire. There follows a further series of extracts from *Tumor Brainiowicz*, with Professor Green eventually taking photos with a machine that seems to be a combination of camera and gun, a long-term connection made by Kantor with several of his objects in other works. A camera-gun appears also in *Wielopole, Wielopole*, as we shall see later. Once again the speech from the Woman Behind the Window comes: 'You children go for a stroll . . .'

This is undercut by the strains of the waltz, on the one hand, and by Maria Stangret now singing a Jewish lullaby, on the other. At this point Wajda has once again moved his camera outside the theatre space into the market square of the Jewish quarter of Krakow known as Kasimierz, where Maria sits singing, accompanied by the clacking balls of the cradle:

Az du vest zain raich zinele
Vest du dich dermonen dos lidele
Rozhenkes mit mandlen ...

Then we are inside the gallery again and into the penultimate scene of the piece. Once again this is the world of Witkiewicz, where there appears to be a kind of free-for-all of both action and dialogue which transforms itself into a parody of a scene from *Tumor Brainiowicz*, where Professor Green, the white chief, arrives at the island of Timor aboard a cruiser called the *Prince Arthur*. As Green enters the room, holding a black pirate's flag, he cries: 'Hooray, let's take possession of this land.'

Then we move into the final section of the piece. The Old Man with a Bicycle enters carrying what looks like a camera, from which emerges a black bellows which he points at various members of the group. Two old men get hold of another and start cleaning his ears by pulling a bit of string back and forth under his bowler hat. Some of the cast start singing 'Eeny meeny miny mo', another shouts a line from *Tumor Brainiowicz* – 'Do you want to become the 5th Marchioness of Micetower?' Strands

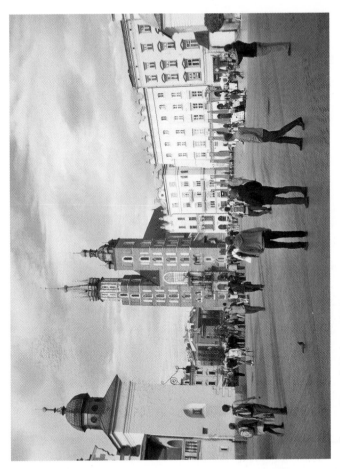

Figure 1 Main Square (Rynek Główny), Krakow, 2009
Photograph by Noel Witts

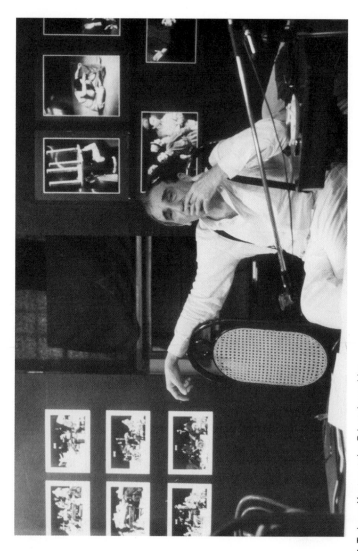

Figure 2 Tadeusz Kantor at the Cricoteka archive

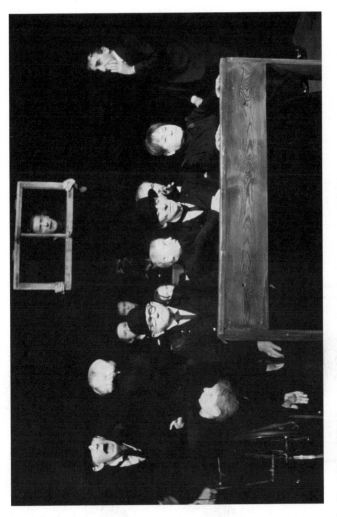

Figure 3 *The Dead Class*, 1975
Photograph by Caroline Rose

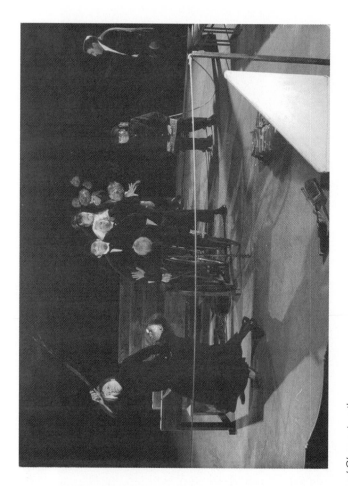

Figure 4 *The Dead Class* enters the space
Photograph by Heinz Dalman

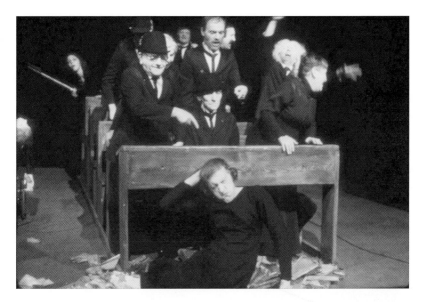

Figure 5 *The Dead Class*
Photograph by Caroline Rose

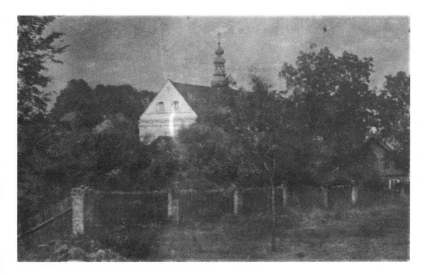

Figure 6 The Catholic church at Wielopole, *c.*1915
Photograph by unknown

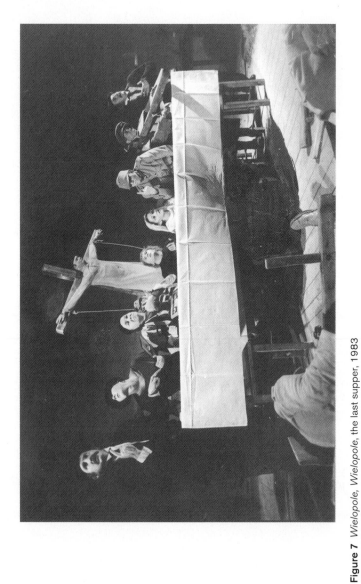

Figure 7 *Wielopole, Wielopole*, the last supper, 1983
Photograph by Maciej Sochor

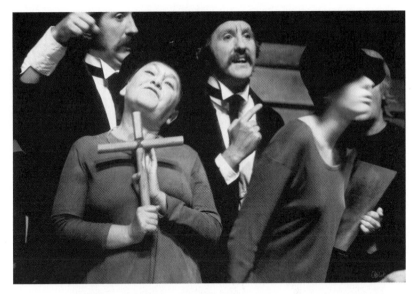

Figure 8 *Wielopole, Wielopole*, the family, 1983
Photograph by Caroline Rose

Figure 9 The Cricoteka archive, Krakow, 2009
Photograph by Noel Witts

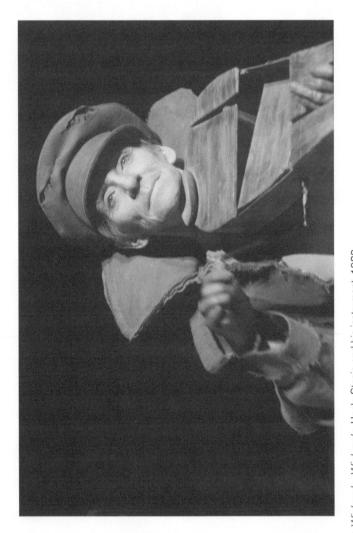

Figure 10 *Wielopole, Wielopole*, Uncle Stasio and his instrument, 1983
Photograph by Caroline Rose

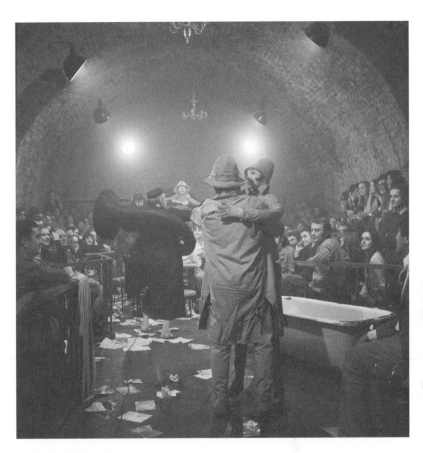

Figure 11 *The Water-Hen* (Witkiewicz), Krysztofory Gallery, 1967
Photograph by Maciej Sochor

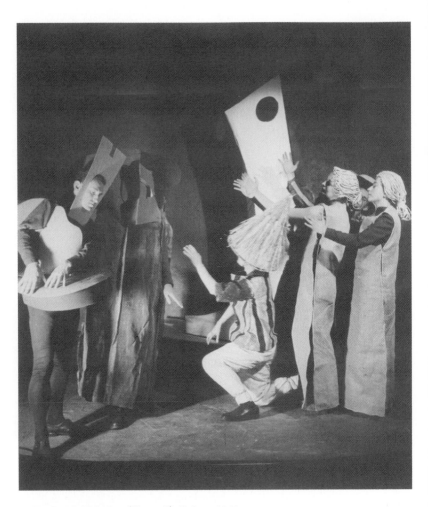

Figure 12 *Balladyna* (Słowacki), Krakow, 1942

Photograph by Witalinski

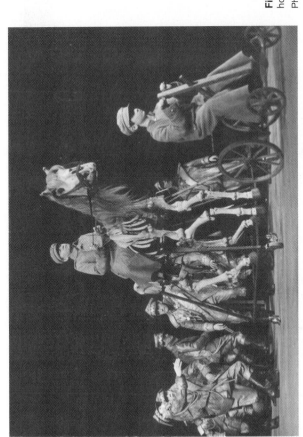

Figure 13 *Let the Artists Die*, Piłsudski's horse, 1987

Photograph by Marek Grotowski

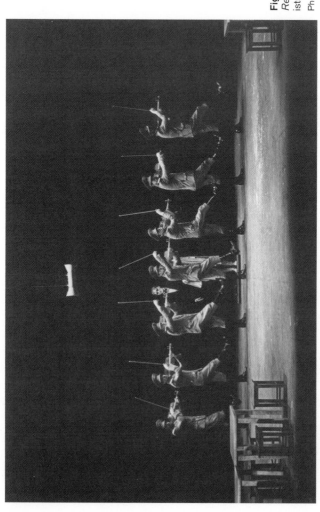

Figure 14 *I Shall Never Return*, the marching violinists, 1989

Photographer unknown

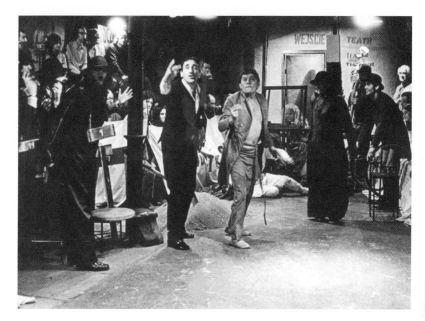

Figure 15 *Lovelies and Dowdies* (Witkiewicz), Edinburgh Festival, 1973
Photograph by Richard Demarco

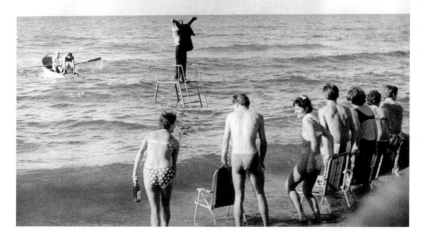

Figure 16 Panoramic Sea Happening, Baltic Sea coast, 1967
Photograph by Josef Piatkowski

Figure 17 Stary Theatre, Krakow, 2009
Photograph by Noel Witts

Figure 18 Słowacki Theatre, Krakow, 2009
Photograph by Noel Witts

Figure 19 *Today is My Birthday*, 1989
Photograph by Caroline Rose

Figure 20 Kantor's grave at the Rakowicki cemetery, Krakow

Photograph by Noel Witts

of previous questions and answers keep being thrown back and forth, while the cast rushes around, falling over and piling on top of each other. The Man with the Bicycle rides in and out, the Woman at the Window looks on with a manic expression, and the Beadle walks back and forth trying to sing the Austrian national anthem. Kantor looks on and then, after a while, freezes the action twice, after which, released, the cast exits still chanting the snatches of sentences that have been started, now heard off stage at the back of the gallery. All that is left are the benches, the tattered books, and the dummy of the Beadle. Kantor exits mysteriously to the backstage gloom, then quietly slips back, standing at the arched exit of the gallery. The noise continues, phrases being repeated over and over, until members of the audience eventually start clapping. Everything is gone, the old people have finally exhausted their memories; there is no order, no music, no resolution to the sequence of images of the séance. The class that died has now disappeared for ever. As Kantor himself once said, 'In the theatre the only living beings are the spectators.' We, the audience, are all that is left of the séance.

The complexity of *The Dead Class* was such that it needed viewing several times. For some audiences it was difficult to realise what kind of 'theatre' this was, and the work was always better understood by visual artists than more orthodox 'theatre' people. But everyone recognised that there was a unique vision here, together with a company of performers many of whom were themselves visual artists of reputation, others of whom were refugees from Poland's official theatres, but all of whom understood the work and could convey Kantor's ideas. An understanding of the literary references was not necessary, though for Polish audiences in 1975 Kantor's use of specific 'underground' authors would have had special significance. But for audiences all over the world Kantor's strange blend of image, sound and music conveyed a palpable sense of an imagined human existence having only memory to confuse it. It also showed that theatre could be a strong combination of image and sound that in some ways approximated more to opera. Audiences could respond to the images of death and decay filtered through the schoolroom with its desks and tattered books. Most people would have had neither translations nor ways of entering the verbal world that Kantor used, but his images of death, the pre-war costume, Surrealist objects, and sheer anarchy crossed with attempts at order struck powerful notes across the world, so that *The Dead Class* was able to emerge from its Polishness and become a universal picture of human memory.

WIELOPOLE, WIELOPOLE (1980)

Wielopole,Wielopole was the next piece created by Kantor and Cricot 2 after *The Dead Class* to tour internationally, becoming Kantor's second great signature work. The title comes from the name of the little town in eastern Poland, or Galicia as it was then, where Kantor was born in 1915. The Polish writer Piotr Krakowski describes the place as:

> a ramshackle Galician backwater with a comical little sloping square surrounded by one-storey houses, a parish church with an eighteenth century tower, and the barely visible remains of the Skrzynski manor house, which the Jews had dismantled at the turn of the century ... Thanks to Kantor's performance, the place became known all over the world.
>
> (Plesniarowicz 2001: 234)

Krzysztof Miklaszewski adds to this:

> Its history was shaped by its geography, merchants in the Middle Ages being attracted by its location on a trade route. Subsequently only military strategists took an interest in it, and then only in time of war. The mercantile 'invasion' was the main reason for its initial prosperity, which was then effectively destroyed by numerous wars, including the Second World War. Hence the history of Wielopole was one of defeat and downfall, rather than ascent and development.
>
> (Miklaszewski 2002: 74)

Wielopole today is strangely like the old photographs – the open square, the Catholic church, the restored manor-house with a small Kantor museum. A visit there takes one to a largely unknown area of Poland – although with the advent of low-cost airlines to nearby Rzeszow it is becoming known as a hiking and holiday area, yet still retaining elements of the old Galicia in its rural architecture.

Once again Kantor's piece is a sequence of actions, this time utilising not Polish literary texts but material written by Kantor himself, as a way of trying to memorise key events from the life of his family seen through a few faded photographs, and more importantly as a discussion and forum for his Theatre of Death. As before, these events can be seen in the form of remembered still photographs which are animated to form a collage of life in a small town family around 1914/15, similar to the period of *The Dead Class*. But here the resemblance ends. *Wielopole, Wielopole*, is an examination of the impossibility of reconstructing dead

memory and at the same time is a fragmented and distorted family history based on a few known facts and images. Also in this case the performers play, or rather play with, the idea of Kantor's family, or his theatrical version of how he saw them from a distance of sixty or so years. The historical elements of war and loss are present, as are the co-existence in one small Polish town of military, Catholic and Jewish elements and characters. But the overall metaphor of war and its disturbances, as well as its sounds of marching and military music, is present throughout the piece.

Wielopole is situated 130 kilometres east of Krakow, near what is today the Ukrainian border. When Kantor was born it was a town that was partly Polish but with a strong Jewish majority. The Polish writer Piotr Krakowski sees the place as being made internationally famous by Kantor:

> In the square stood a chapel with some sort of saint for the Catholic faithful. In the same square was a well near which Jewish weddings were held, primarily when the moon was full. On one side stood the church, the rectory [in which Kantor was born], and the Catholic cemetery, and on the other the synagogue, the narrow Jewish lanes, and another cemetery. Both sides existed in harmonious symbiosis. Aside from its daily life, the town was oriented toward eternity.
> (Plesniarowicz 2001: 11)

Wielopole,Wielopole takes this place and Kantor's own family history as partly remembered by the artist, and gives us a deliberately distorted and grotesque picture of the everyday lives and traumas faced by a community confronted at that time with the consequences of war. A platoon of Polish conscript soldiers is on stage for much of the time, and a military march and marching feet dominate, prefacing the final image of the Jewish Rabbi helping the Catholic Priest off stage in a gesture of reconciliation – perhaps the only note of optimism in the entire piece.

As with *The Dead Class*, the playing area is constructed of rough materials, in this case a platform of rough boards on which stand elements of a room – chairs, a wardrobe, a bed, a pair of slatted wooden doors which open to a blank space at the back of the stage. The whole represents what Kantor calls a 'dead room inhabited by the dead . . . stamped into the memory for eternity'. The piece, however, is a series of memory fragments which, like memory, follow no logical order, but which together make up a commentary on memory. The various versions of the piece that have been filmed (and which form our major reference

points) differ somewhat from each other and from Kantor's published scenario, so the account I give is based on what appear to be the major elements common to all versions.

The piece begins with Kantor, in his trademark black suit and scarf and white shirt, arranging the furniture of the room of his childhood, watched by the members of his family grouped in what might be the pose for a family photograph. Kantor's unspoken introduction goes as follows:

> Here is my Grandmother, my
> Mother's mother, Katarzyna
> And that's her brother
> The Priest
> Some used to call him uncle.
> He will die shortly.
> My father sits over there.
> The first from the left
> On the reverse of this
> Photograph he sends his
> Greetings
> Date: 12 September 1914
> Mother Helka will be here any
> Minute
> The rest are Uncles and Aunts.
> They went the way of all flesh,
> Somewhere in the world
> Now they are in the room,
> Imprinted as memories:
> Uncle Karol, Uncle Olek,
> Auntie Manka, Auntie Jozka.
> From this moment on, their
> Fortunes begin to change
> Passing through a series of
> Radical alterations,
> Often quite embarrassing, such
> As they would have been unable
> To face, had they been among
> The living.

(Kantor 1990: 18)

So the characters are both the living and the dead, though all are now dead, and it is possible that none of these events happened with all of

them present: a typical commentary by Kantor therefore, which resembles the Jewish idea of a *midrash*, or commentary on established and accepted teachings. Although it is now clear that Kantor was not himself Jewish, there was enough observation and inculcation of Jewish experience in him to help suggest this possible Jewish focus in his work.

The first scene is one where Uncle Olek and Uncle Karol, both in formal black dress and wearing stark white makeup, run back and forth, asking if the photo of the family was correct. They are played by the Janicki twins, who were major performers in the Cricot 2 company for many years:

> Surely, Uncle Olek wasn't
> Sitting down, was he?
> He was standing, or walking …
>
> The suitcase was on the
> Wardrobe …
> What about that chair?

Much of the two uncles' function throughout the piece is to run around, placing and displacing objects, dressing and undressing, trying to bring some order to their memories and the events going on around them, and at the same time representing what Kantor sees as the useless daily family concerns. In the same space is the revolving iron bed on which Uncle Jozef, the dying Catholic priest, is laid, while Grandma sings Psalm 110 to him, at the same time inserting a metal bedpan under his body. The wooden slatted door at the rear of the playing area opens for a brief moment to reveal the dead body of a woman in a wedding gown, Kantor's mother Helka. There is also a female photographer with a 'bizarre rattling tin camera', who is not allowed to enter the room because she is stopped by Grandma.

The performers in *Wielopole, Wielopole*, according to Kantor, do not so much play as impersonate:

> The principle of impersonation can be generalised as a method. Thanks to it, the actors in Cricot 2 do not have to act. Everyone who impersonates someone does it badly, and ends up playing himself because it is impossible to be transformed. Transformation that's the most boring method in conventional theatre.
> (Plesniarowicz 2001: 235)

But we can see that in this piece there is a greater approximation to what might be called 'character' – members of the family – than there ever was in *The Dead Class*. This is a piece of distorted family history which yet is close to both real public and private events in a small town in Poland at the beginning of the First World War.

Grandma now repeats the psalm as well as her action with the bedpan, but in comes the photographer, who is actually the widow of the owner of the local photographic studio (known as 'Ricordo'):

> and a foul skivvy from the parish charnel house, rolled into one. A dismal agent of death, bluntly thrusting in her hooded handcart with a built-in camera. She behaves in a careless, slapdash fashion, showing the typical callousness of her trade.
>
> (Kantor 1990: 27)

Grandma exits, leaving the photographer to perform some Kantorian exercise in which she shows us that the bed upon which the dying Priest is resting is actually a piece of revolving machinery: the top can rotate around a shaft, which ends in cog-wheels and a crank. As the photographer turns the crank, the dead Priest disappears, to be replaced by a performer as the Priest emerging from underneath. This time he is dressed ceremonially. The photographer props the Priest up and brutally twists his head to the camera, takes two shots, then steps up to the door and, stomping around, controls our vision in the way that commercial photographers often do. This deathbed is therefore another example of one of Kantor's bio-objects, where the machine-like elements transform both the performer and the spectator's vision of what is happening, and which effectively blurs life with death in one visual image.

Now the family members enter again, presenting another family picture. The photo is taken, and the family disappears behind the closed doors. At the side of the room stands the platoon of conscripts waiting to be sent to the war – another remembered image of Wielopole at that time. They wear combat fatigues and each carries a gun. According to Kantor they are:

> pathetic nondescript figures in full uniform, with rifles. Illegal tenants of the room since childhood, they arrive from the past, reduced to a single pose and single moment of a photograph. There is something rudimentary about these dwellers on the margins or life and memory.
>
> (Kantor 1990: 31)

The platoon of soldiers sits there, shaking in an image of exaggerated fear, and the camera, in one of Kantor's object transformations, becomes a machine gun, accompanied by the photographer's shouting voice, which is reminiscent of the sound of the 'old' children in *The Dead Class*. This platoon often dominates the piece, with sections of grotesque marching serving to remind us of the military context of the entire performance. The Priest now points across the stage to Marian Kantor, the father, sitting in the front row of the platoon, expressionless. The Priest begins a lengthy section in which he tries to teach Marian how to march properly, accompanied by a Polish military march known as *The Grey Infantry*. The whole effect is of a ludicrous attempt at making a dead image come to life, until the staggering movements that Marian manages (and which are to become his trademark gesture) themselves defy any real existence. By now the Priest has been given a huge wooden cross on his back which accompanies his own attempt at marching. Images of crosses and marching men become the leitmotifs of this extraordinary piece from now on.

The Priest goes and opens the wooden doors, behind which lies the dead bride, Kantor's mother Helka, all in white, sometimes torn, with her pathetic veil. The Priest lifts her, props her up, and drags her forward into the room, where it is time to conduct the marriage service with Marian. He props Helka next to Marian, reaches into his pocket for the marriage service, and begins:

Marian Kantor!
Wilt you take this woman
Helena Berger
To thy wedded wife to live
Together
After God's ordinance in the
Holy
Estate of matrimony?

Mother Helka can only respond in a puppet like voice. Father Marian, according to Kantor, 'can utter nothing but a hideous animal gibber, choking with the effort of remembering the human voice. Thus unfolds the dialogue of the quick and the dead' (Kantor 1990: 37). The effect of this terrifying moment is to disrupt completely the image of the marriage ceremony, while at the same time making a comment on the fact that Kantor's father never came back after the war, but settled in Silesia and finally returned to Tarnow, near Krakow, and ended up in Auschwitz for distributing an underground newspaper.

Kantor gave the next section the overall title 'Vilification', by which he meant the family's shame at the knowledge that Marian had deserted Helka. Images of Marian's return to the family while on leave end in the family's making Helka a sacrificial victim on the cross at Golgotha. Helka is now seen sitting on a kind of mobile scaffold which is on a push cart. The family keeps pushing this thing around while Mad Auntie Manka begins to speak the words of the Gospels, 'as she does whenever a crisis befalls this terrible family':

> Oh Helka, Helka!
> Why did he degrade you
> And so meanly desert you …
> Perhaps it serves you right
> To be so degraded,
> Debased, defiled and abused.
> How are the mighty fallen! …
> When the morning was come,
> Pilate had him scourged,
> They put a crown of thorns upon his head
> And they spat upon him and mocked him
> And smote him on the head and the kidneys.
> Oh Wretched Helka
> Wretch indeed,
> To have come to this in the
> End.

(Kantor 1990: 48)

The platoon advances from all sides of the space, encircling the family as if to trample them underfoot. The family leaves and a dummy of Helka appears above the soldiers' heads. The soldiers throw her up in the air, leaving her with her arms and legs 'shamelessly flung apart'. At this point Uncle Stasio, the Deportee, enters slowly, skirting the back of the stage near the doors, playing a tune by Chopin on his violin. The family leaves the room slowly and disappears behind the door. Helka is left on the floor, dead, raped, her knees apart. Once again we are aware of the mix of farce, tragedy, prejudice and religious bigotry, contrasted with the formal musical elements of chant, march and piano piece which form the framework of this piece of theatre.

Wielopole, Wielopole as a title is now becoming a wail of shame, the family being clearly implicated in the disaster that was Helka's marriage

and their consequent humiliation. They now enter and argue about the marriage, about Helka's dowry and Marian's defection. All the time Marian is performing a grotesque march around the stage like some demented statue, yet the family tells us that a postcard from him has just come with its seasonal message. How far, we wonder, was this grotesque family story a form of therapy for Kantor, who as a small boy remembered these intolerable events, framed against the precepts of a Catholic upbringing? His mother died in Krakow as late as 1962 while Kantor was abroad, and he was therefore apparently unable to attend the funeral. One wonders how far *Wielopole, Wielopole*, created twenty years later, was his ambiguous tribute to this determined woman.

The next section is entitled 'Crucifixion', and we now see the two uncles in a scene entitled 'the repetition of the commonplace', where they are both busy dressing and undressing, repeating questions of dress protocol:

A waistcoat under a jacket
Though lacking a jacket
Under a coat
Off I go with a waistcoat on
etc. etc.

There are more religious forebodings from Auntie Manka, and a scene where young Adas is sent to the front while the family debate what they can do:

Well, something must be done
To help him out,
To obtain his release
We'll have to think of something,
Make him stay put, maybe
Just watching the world go by
Or doing a bit of gardening …
The best idea is medical grounds,
Say varicose veins …
What have varicose veins to do
With war?
We are all under one banner!
On the pages of history!
We shall not give in!
Forward march!

(Kantor 1990: 73)

Now the Deportee-cum-Busker (Uncle Stasio) turns up. He has nothing left but a violin case in which is concealed a hurdy-gurdy. He turns a crank of the machine and we hear the distorted version of Chopin's B Minor Scherzo, a strange echo of a more civilised and aristocratic Poland, to try and calm the panic. The Priest comes back with a cross, on top of which is strapped Adas's body.

Next comes the court martial of the Priest, who is set with his back to the audience. He is facing the entire platoon, who threaten him with wooden rattles, the sound of which fill the stage. The two uncles and a platoon officer (Auntie Hanka) pass judgement on the Priest. The wooden clatter sounds like a death rattle and the Priest is symbolically shot by the platoon. The family history now becomes intertwined with military rituals of control and destruction.

The last section is called 'The Last Supper', and is preceded by images in which the death-bed machine wreaks oral havoc among the family: on top the dummy of the Priest, underneath the performer playing the Priest. The family is split into two groups, one taking the side of the dummy-Priest, the other that of the performer-Priest. They creep on the floor and peep under the bed as they keep turning the machine:

> Here they go again
> My head's turning
> He is not one of ours
> It's not him
> What does it matter
> Up and down up and down.

(Kantor 1990: 83)

All this is absurd and, as Kantor says, 'inexplicable'. The room of childhood suddenly becomes a room of turmoil; the family members bring in and arrange chairs and crosses, the soldiers being now accompanied by their dummy doubles as children, wearing priests' birettas and holding rifles. They sway above the marching platoon, which is circling the stage. From behind suddenly comes the Little Rabbi, played by Maria Stangret, singing a kind of music-hall funeral song and wringing his hands in despair:

> Sha Sha Sha de Rebe
> Gite
> Sha Sha Sha bam reben

Stite
Der shames ba dy tur
In di Rebezn oy is duisa
Oy Oy Oy
Oy Oy Oy

(Kantor 1990: 86)

The soldiers take aim and fire and the Rabbi falls to the ground. The Priest lifts up the Rabbi. The Rabbi takes up his song again. Another volley and he collapses. This goes on a number of times, then the Rabbi leaves. Mad Auntie Manka enters wearing a uniform and marches round the room uttering commands in an unknown language that sounds like a dog barking. The soldiers keep marching until Auntie Manka exits, after which they fall to the ground. The *Grey Military March*, which has been accompanying all this, suddenly stops. It is replaced by the psalm sung by a congregation, which is followed by the entry of the family once again: 'There is a distinctive air about the way they enter this time, quite different from that of all previous entrances. You can feel that they are arriving here for the last time, and with a special purpose in mind' (Kantor 1990: 90).

They all begin to line up chairs, collecting them from all over the room. Marian Kantor measures all that comes his way with his broken ruler. Behind the row of chairs are the naked dummies, behind them a pile of crosses, and further off the army with their rifles. The family members take their place downstage. Suddenly the two uncles rush out and return with an enormous board swaying over the assembled company. Next two soldiers arrive with another board, and the two boards end up at the front of the stage, propped up by the performers. The family persist with their arguments while the psalm continues, but it is now clear that we are about to see the Kantor family as Leonardo's *Last Supper*, a kind of blasphemous image reminiscent of Luis Buñuel's film *Viridiana* of 1961, where the Last Supper consists of a crowd of beggars who have been introduced into the grand house to create chaos.

Finally an immaculately starched white cloth is introduced and laid on the boards to complete the picture. The noise increases: the soldiers have grown insubordinate and they push everything to the edge of the stage – the wardrobe, the table, the chairs, the window, the bed – 'a monstrous pulp of wreckage'. They then exit through the wardrobe, and there are naked corpses of soldiers lying on the floor. Uncle Stasio enters with his violin and we hear again the Chopin music. Slowly the performers retreat from the stage, moving backwards, looking behind

them. The Priest remains on the ground under the table. Then from the back comes the Little Rabbi in his synagogue garments. He approaches the Priest, helps him up, and leads him away, Jew and Christian together leaving the room of Kantor's childhood. Uncle Stasio follows behind with his distorted Chopin. Kantor goes up to the table and very carefully folds the white table-cloth. He sticks it under his arm and with a sweep of his right hand goes out, banging the doors to the room behind him.

So ends another of the great imagistic pieces of twentieth-century European theatre – on one level a distorted Polish family tale, but to international audiences an emblem of European history, militarism, religious prejudice and family destruction which speaks even now across the decades and generations.

LET THE ARTISTS DIE (1986)

This was the piece that Kantor made five years after *Wielopole, Wielopole* and which originated in Germany, then toured to Italy, France, Spain, the Netherlands, Argentina and Japan, and had its Polish premiere at the Słowacki Theatre in Krakow. This was an immense leap for Kantor, who had always avoided official theatre spaces, but in fact showed the increased status which his work had now achieved in his home country. There is a touching photograph of Kantor, with an ironic smile on his face, climbing up onto the stage of this grand theatre to set the design, and another of the Słowacki Theatre audience in their gilt boxes applauding this invasion of an alternative vision of what theatre could be.

Let the Artists Die was commissioned by, among others, Karl Schmidt, a Nuremberg banker who was a great follower of Kantor's work. One of the figures in the piece is the Nuremberg sculptor Veit Stoss, who made the famous altarpiece in the Church of the Blessed Virgin in Krakow. The story goes that Veit Stoss had a nail driven through his cheeks as punishment for financial malpractice in his home town, an image of which appears during the piece. Kantor himself called *Let the Artists Die* a 'review', which indicates not simply a light-hearted collection of sketches – which it is not – but also a review of many of Kantor's productions and obsessions from a life lived on what we have already described as one of the faultlines of Europe. Thus we have references to attempts to gain Polish independence in the nineteenth century, references to the family from *Wielopole, Wielopole*, a plethora of objects of varying types and from varying theatre pieces by Kantor, many moveable

travelling wooden crates symbolising the wanderings in the world of the Cricot 2 company, and a theatrical format which appears to be a random collection of images from Kantor's mind. The piece was seen as the last part of what Kantor considered the Theatre of Death trilogy, and is clearly yet another experiment in constructing stage meaning from memory. In some ways it is the most difficult of Kantor's pieces for a non-Polish audience, but its virtuosity and invention is so breathtaking that one is content simply to watch the various images passing in front of one's eyes – the grand parades, the Janicki twins' word games, the entries of 'Marshal Piłsudski' on the skeleton of his horse, accompanied by a set of Polish generals and with Kantor as a six-year-old boy on a wooden tricycle – to name but a few moments. The title was said to come either from a remark made by a Parisian maiden lady who lived next to the Gallerie de France where Kantor exhibited, or from a cleaning lady confronted by the chaos of a private view – 'Qu'ils crèvent les artistes'.

In his commentary on the piece in the 'Guide de Spectacle' produced for the performances, Kantor wrote:

> one will find neither the setting nor the action on this stage.
> in their stead, there will be a journey into the past, into the abyss of memory,
> into the past time that is gone irrevocably but that still attracts us,
> into the past time that floats into the regions of DREAMS, INFERNUM,
> THE WORLD OF THE DEAD, AND ETERNITY
>
> (Kobialka 1993: 340)

The stage has one wooden door for all the entries, a bed, chairs, and a set of wooden crosses placed towards the back of the stage. They are 'crosses of a country cemetery as if I was searching for other secrets'. Kantor sits stage right on a small chair. The door opens and in comes the gaoler, or, as Kantor interprets him, Charon, the boatman who, in Greek mythology, ferries the dead across the river. The stage is described again by Kantor as his 'Poor Room of the Imagination', without walls, without floor or ceiling – a site for recollection. The family members from Wielopole now enter – the same dark costumes, the same movements – and proceed to dress the corpse of someone who has died. Dr Asklepios, in black with a beard and hat, played by Mira Rychlicka, now enters and checks the pulse of the dead man. Asklepios was the Greek god of medicine who had the power of restoring the dead to life, but in this context he comes from one of Kantor's school memories of his class, of one who has aged and has no more work in this

house of death than to check the pulse. Asklepios enters from time to time throughout the piece and takes a pulse wherever a hand hangs loose – one gesture repeated frantically.

If we regard these images as photographic memory plates of Kantor's past, then the next image is the entry of Kantor himself as a six-year-old boy, propelling himself on a wooden tricycle to the front of the stage as if checking the space, after which enters the extraordinary presence of Marshal Piłsudski, played by a woman, seated on the skeleton of his famous chestnut mare, Kasztanka. Piłsudski was the head of state from 1918 to 1922 and later the leader of the Second Polish Republic, from 1926 to 1935; thus throughout the period of Kantor's childhood he was *the* major Polish political leader. After his death a funeral train toured Poland, and now Kantor's image of the horse skeleton being accompanied by a set of generals in Polish four-cornered hats is clearly a memory of a photograph from the period. The music, a patriotic march from the First World War entitled *First Brigade*, was Piłsudski's funeral march, and accompanies the procession of small boy, horse, rider and generals. It is played by what sounds like an army band and reappears throughout the piece, sometimes in a slowed-down version. Kantor said of it:

> The Fame and Glory of the past are recognisable only in a fragmentary form. I grasped this when, fascinated by the Leader's funeral march, I became the owner of a damaged gramophone recording of this lofty and moving march, which made the piece both thrilling and repulsive at the same time.
>
> (Miklaszewski 2002: 119)

Here it represents a rather hopeful Polish victory. However, Plesniarowicz points out that the group image of the generals might also recall the mass graves of thousands of Polish army officers discovered at Katyn in 1940. Kantor wrote in his programme guide: 'It is impossible to say whether it is a victory parade or a funeral procession for the pride of the nation.'

The soldiers exit robotically, leaving the horse and rider plus the boy-Kantor, and Dr Asklepios rushes in, taking everyone's pulse and behaving like a manic traffic controller, when suddenly there is the sound of an Argentinian tango and the wandering players of Cricot 2 appear, heralding the start of Act II. They arrive with a series of prop and costume boxes, one marked 'NÜRNBERG'. They appear to be characters and (bio)objects from Kantor's past performances – the Hanged

Man with his gallows, one who is addicted to card-playing, a Religious Bigot with her kneeling desk and rosary, a Dishwasher with her sink, and others, all of whom proceed to try and memorise moments from their past lives. The Angel of Death/Batwoman presents a Kantorian chorus of sound and moving image which is stopped for a moment by the sound of a Jewish song with accordion, sung by the soldier sitting on Piłsudski's horse (Maria Stangret, Kantor's wife).

Kantor described the method of creating this piece:

> The performance very often has to take shape during the course of rehearsals, through the actors, their actions, their bodies, their feelings. We might be able to find in the performance from time to time distant echoes of this character or the remains of that literary text. But this is not because we are transferring a literary work to the stage. It has much more to do with my basic practice of not relying on some 'constructed' or 'composed' reality, but of operating with a 'ready-made' (*prête*) reality, and with characters and objects which have been 'found' (*objets trouvés*).

(Miklaszewski 2002: 114)

One of Kantor's inspirations for the piece was an obscure novel published in 1932 by Zbigniew Unilowski, *The Common Room*, where throughout the reader is a witness of the hero dying. Thus the visual actions of the wandering Cricot 2 performers now take place in a room of the dying characters of Kantor's performance memory, where the Janicki twins play with the idea of death, the doctor and the bedroom: 'In this production I wanted dying to be the "binding" of various manifestations of life, almost constituting the structure of the whole' (Miklaszewski 2002: 114) .

The characters now proceed to create one of Kantor's Grand Circles, where performers and objects circle the stage to the sound of the military march, joined by Piłsudski, his horse and generals – a kind of visual memory of the show's motifs so far, reminding us also of the links between each character and his or her actions, objects and costumes. Then the wooden door at the back of the stage begins to move forward to the sound of a Jewish/Polish religious chant, and two characters dressed in black walk through to the front of the stage. One of these wears a long black cloak and fedora hat and clutches a wooden cross. This is the entry of Veit Stoss, the Nuremberg sculptor who is to dominate the rest of the piece. He drags the Angel of Death up from her bed to perform a tango, and the two go off through what is now clearly the door to some kind of underworld.

Now comes the entry of the torture machines – strange wooden contraptions which look like something out of the Spanish Inquisition, to which each of the actors is strapped to the sound of the march. This is all supervised by Veit Stoss as if he were assembling some of his statues at the Church of St Mary in Krakow. Kantor's series of drawings entitled *Man Bound up with Objects* is clearly the source of these images. Stoss tangos once again with the Angel of Death, who now has a set of metal wings strapped to her as she mounts Piłsudski's horse to exit with the tortured actors, followed by Dr Asklepios.

There is then a re-entry of performers, who commence a routine of tapping wood on wood around the objects, a sequence which suggest ideas of the death rattle of a dying person. This transforms into the collection of all the objects and persons on stage to create a massive barricade, with the Angel of Death on top waving a flag. Clearly based on Delacroix's painting of 1830 *Liberty Leading the People*, it also refers to the Polish uprising that year against the Russians, and is accompanied by the military march which has been so dominant throughout the piece. One by one the actors climb down from the barricade and exit, followed by Kantor, who closes the piece with a hand gesture, and by Veit Stoss.

Let the Artists Die is one of the most complex and self-referential of Kantor's works, but is also the one where we can most clearly see the close relation between actor/character and object. Throughout the piece objects are used as integral, predominantly moving, elements in the picture, and it is interesting that at the end all of them are piled up as if their life is over after being part of an image of liberty: it appears as if it might be considered Kantor's last stage image of finality, although there were two more major pieces to come.

I SHALL NEVER RETURN (1988)

This was the last completed major piece that Kantor saw finished (he was still in rehearsal for *Today is My Birthday* when he died in 1990) and seems to be another collecting together of memories of many of his past pieces, images and characters in a strange Surrealist cabaret – he called it a personal confession – held together by a hypnotic tango – Tango Argentinian by Canaro – played on piano, accordion and violin. It was given its Polish premiere at the Stary Theatre in Krakow, Poland's major prestigious venue, once again emphasising the bowing of the state to the evident international fame of Cricot 2 and the demands of an

audience, members of which were by now heralding the eventual downfall of communism in Poland. There is a touching photograph of a well-heeled audience at the theatre observing this strange acceptance back home of its major artistic exile.

One critic in Marseilles wrote of the piece: 'a seventy-three year old man recapitulates his life, mingling it with the history of his works. Poland as seen through the eyes of this man is universal, embracing the whole of mankind'. Plesniarowicz describes it as:

> A deliberate historical conclusion of the cycle that runs from the occupation production of *The Return of Odysseus* (1944) through the Theatre of Death trilogy (1975–85). So the 'eternal pupils' return to the benches of the dead class-room to make one more attempt at playing a work of Wyspianski's. Visited with amnesia, however, they cannot remember their parts despite the prompting of the Priest, the leader of the whole group.
>
> (Plesniarowicz 2001: 260)

The stage in this case has become the interior of an inn or some abstract space, with simple wooden chairs, tables with sheets of tin on top, and a host of shady characters – an old waiter, a mad half-naked washerwoman, a priest who seems to come from Wielopole asleep at a table, and a drunk who delivers a slurred speech to the tango accompaniment, and so on. The tango brings on the collection of characters from old Kantor productions – *The Water-Hen*, *Dainty Shapes and Hairy Apes*, *Wielopole, Wielopole*, and *Let the Artists Die* – all quotations from the life of Cricot 2. The space is transformed from the inn into a poor classroom and a dressing room, with shards of past actions and sound meshing together. At one point all the performers sit at the school benches from *The Dead Class* and attempt to reprise parts of the show.

One image that returns several times is that of 'the Armoured Orchestra of Violinists', a terrifying row of eight musicians in Nazi uniforms with high boots and an identical rhythmic parade step, moving their violin bows in an automatic manner across the violins that they hold like dead objects. Their march is repeated over and over again as they cross the stage. On one occasion it is played out against the medieval Hebrew song 'Ani Maanim' (I am a Believer), sung by the Jews on the way to the gas chambers. In this instance the Nazi orchestra leads their victim, Samuel, who is also followed by the Dishwasher, who shouts the words of the song: 'Ani maanim, ani maanim, beemuno shleimo bevies hamoshiach bechol zos hamoschiach veaf al pi sheyismamel in

kol zos ani maanim' (I believe fully in the coming of the Messiah, and even though he is slow to come I expect him). The impact of these contrasting images, connected with some kind of historical memory, is overwhelming. In Kantor's own words from his programme notes:

> A nightmarish march of phantoms
> From the 'Band of Ironclad violinists'
> Unplanned by the innkeeper
> Well-known uniforms
> Legs in patent-leather knee-tops
> Thrown upwards
> Iron fiddles
> And fiddlesticks – going up and down
> And in order to complete this nightmare,
> The Rabbi is running in front of them,
> Schmul, dragged from his synagogue at Wielopole
> Mad with fear
> He is conducting
> His executioners.

(Halczak c. 1990: 193)

At the end of this strange piece there is a prolonged wrapping up of all the characters in what Kantor called the 'Grand Emballage of the end of the Twentieth Century' to the entire length of the Rakoczy March from Berlioz's *The Damnation of Faust*. The characters are chased under an enormous black blanket by some of the cast who are wearing formal frock coats – 'These Serious Gentlemen' – egged on by Kantor himself, who seems to be orchestrating the entire scene, accompanied by a woman in riding gear with long blonde hair and a top hat.

> MADAM. It is uncertain whether she belongs
> To them or else
> Rules them …
> And maybe she rules
> The entire performance.

(Halczak c. 1990: 193)

As always the frantic music gives the whole scene an air of panic, as if this really is the end of their (fictitious) lives and the end of Kantor's own memories. Kantor wrote in the programme notes to this piece: 'I gave them life, but they also gave their own. They were not easy or obedient.'

The Polish critic Bronislaw Mamon wrote about *I Shall Never Return* in February 1990, eight months before Kantor's death, attempting to sum up the latter's attitude to the socialist society in which he was supposed to have functioned:

> During the 45 year long period of 'real' socialism Kantor has suffered various injustices on the part of people responsible for the so-called 'cultural policy'. They resented him because he was always himself, because he loved his own art and independence, because he had never joined the ranks of those who – in a joyous rapture – were building the utopia of a happy society. He was blamed for many grave offences, namely for being narcissistic, egotistical and cosmopolitan, for not having enough patriotism and respect for 'the common man'. He was classified as a member of the species of escapists, outsiders, aliens. Those who said so understood the artistic presence very narrowly and one-dimensionally. In their opinion the 'artistic presence' was equalled with a duplication of ideological schemata and the resulting elevation of reality. From the perspective of the present time we can see how fallacious all those dogmas proved to be. It is enough to have a look at the performance *I Shall Never Return* to become convinced of it.
>
> (Halczak *c.* 1990: 195)

In conclusion we may once again emphasise that, for someone brought up in a tradition of literary theatre – the all too dominant form in the UK, for example – viewing Kantor's theatre has never been particularly easy. It is good that there are generations of viewers now who are used to multiple meanings in works of the performing arts, who can look at performance with an eye schooled in the visual arts, and who, in many cases, make no distinction between a piece of text-based theatre and a performance which may be visually based. The most difficult task in viewing Kantor's work is to resist the temptation to try and convert every visual image into a language of explanation or interpretation. If this is the dominant approach, then everything which is untranslatable into literary meaning becomes questionable – Why the marching Nazis? Why the tangoing cardinals? – or else treated as nonsense. And so it is better to stop asking those questions, to stop asking precisely what it means, what thought lies behind it, what the director really meant to say. In the words of Bronislaw Marmon: 'This theatre should be either received as a poetic magic, or not received at all.'

PRACTICAL EXERCISES

INTRODUCTION

This chapter, in common with the other subjects in this Performance Practitioners series, deals with a set of possible exercises that students may use in order to work or train in the manner of the artist concerned. In the cases of Meyerhold, Lecoq, Michael Chekov, Stanislavsky and many others, there is a legacy of practice that has been handed down by followers or, in some cases, a system of exercises. In the case of Kantor there is no legacy of practical exercises apart from a few attached to his series of *Milano Lessons* from 1988, where he partially recorded what he did with those particular students. Otherwise there is a mass of manifestos and essays, a few of which deal with practical matters, and some memories of those who worked with him over the years in the Cricot 2 company. What we do have is a collection of strategies for the creation of theatre work and some records of Kantor in rehearsal. And we also have his unique archive, the Cricoteka, which provides us with much evidence for an appreciation of his working method via the collection of tapes, and now DVDs, of most of the later performances. Of the earlier work there are sets of photographs and drawings; in addition there is a large collection of Kantorian objects, some of which are on permanent display, some of which can be seen in the Cricot 2 storeroom by appointment. It is worth considering this collection via a statement made by Kantor himself when he set up the archive in 1987:

> The idea of the Centre of the Cricot 2 Theatre has been devised by me as the LIVING ARCHIVES, which will preserve, complete, and transmit the material collected during my creative and theatrical work as a living load of the idea of a new theatre. I am of the opinion that it is indispensable for the development of theatrical culture to preserve the ideas not in a dead library system but in the minds and imagination of the next generation. Over several years I have educated a scholarly staff able to fulfil the above mentioned functions.
>
> (Halczak c. 1990: 221)

The Cricoteka archive is now housed mostly in ulica Kanonicza, where it was originally placed, and there is a branch at ulica Sienna in the flat where Kantor lived during his last years, and where he died. The bedroom is still as he left it, with the book by Genet that he was reading on the bedside table. In the neighbouring studio there are posters and drawings, and you can watch the performances on DVD courtesy of Jolanta Janas, who also worked with Kantor in the archive and who now supervises this part of the Cricoteka. Kantor insisted that the archive be directed by Anna Halczak, who is still in post, and has helped me in the research for this book, and Bogdan Renczynski, who was a member of the Cricot 2 company in its latest years. There is thus a direct link with Kantor's practice via those who look after his legacy, those 'scholarly staff' whom he trained. Slowly since Kantor's death some of the many films and videos of his work have been transferred to DVD, particularly the work of the Polish film-maker Andrejz Sapija, who filmed the last rehearsals of *Today is My Birthday* (1990), *Let the Artists Die* (1988) *I Shall Never Return* (1988), *Ou sont les neiges d'antan?* (1984), and *Wielopole,Wielopole* (1983). The famous film of *The Dead Class* made by Andrejz Wajda has also now been transferred to DVD. There are German films by Mahlow, Kluth and Bialko, Denis Bablet's 1991 film *The Theatre of Tadeusz Kantor*, and extensive film of Kantor rehearsing *Let the Artists Die* in 1988, as well as a collection of films made for Polish television by Krzysztof Miklaszewski, who appeared in the original version of *The Dead Class* and many other performances. There is also material from Italy, where Kantor prepared several of his pieces. This obsessive filming of his work, together with a complete collection of written reviews from all over the world, make the archive incomparable as a record of an artist's finished work, but, for clues as to the actual creative process, any English-speaking student has to go either to the artists who worked with him or to two particular Polish scholars who have had access to letters and journals which they themselves have translated into English.

The first is Krzysztof Plesniarowicz, who was the first director of the Cricoteka after Kantor's death in 1990. His book *The Dead Memory Machine* was first published in an English translation in 1994, and is an invaluable source of descriptions of performances, translations of letters and essays, interviews, and commentaries. Plesniarowicz allows us to enter Kantor's Polish world in a way that, to date, no other scholar has attempted. There is as yet no full biography of Kantor, so that Plesniarowicz becomes our essential guide to the artist's mind. Supplementing this is Michal Kobialka's book *A Journey through Other Spaces*, published in America in 1993. Kobialka is a professor at the University of Minnesota and the foremost Kantor scholar outside Poland. His book is a valuable source of translations of many of Kantor's most important manifestos as well as an important description of Kantor's last work, *Today is My Birthday*. Together Plesniarowicz and Kobialka have made possible this introductory book to Kantor. The Cricoteka archive also houses books and articles in French by Guy Scarpetta and Denis Bablet, plus some material in Italian, all of which may give different insights into Kantor's processes. Here we can provide only some clues from talking to both his company members and to those who have followed on. As Kantor himself wrote of the Cricoteka: 'Only an individual place of this kind rather than a museum can express the full truth about the artist's oeuvre' (Halczak *c*.1990: 219)

The irony is that a major museum dedicated to the work of Tadeusz Kantor is under construction near the River Vistula as I write.

KANTOR AND TEACHING

Although Kantor taught art on at least two occasions (1948 and 1968) at the Krakow Academy of Fine Arts (his appointment as professor both times was revoked within a year!), he never saw himself in a traditional teaching role, left no set of procedures or exercises for students to devise theatre works, and provided no written clues as to how he created his work. However he did work with students on at least three occasions. The first project was a performance in 1986 entitled *Wedding Ceremony*, which he produced with the students of Civica Scuola d'Arte Drammatica in Milan; the second was a month-long project for a multinational group of mime artists, performers and puppeteers at the Institute of Marionettes in Charleville-Mézières; and the third was the piece called *Ô douce nuit*, which was created at the Chapelle des

Pénitents Blancs in Avignon in 1990. Richard Demarco also persuaded him to offer a practical workshop (alongside one by Joseph Beuys) when he presented his early work at the Edinburgh Fringe in the 1970s.

Unlike many of the other artists represented so far in this Performance Practitioners series, there is no firm model for any practical work to be undertaken by students. However there are several key artists – Zofia Kalinska, Andrejz Welminski, Ludmila Ryba, Marie Vayssière – from Kantor's own Cricot 2 company who continue to conduct practical workshops examining the theatre of Kantor, and sets of self-generated exercises to help. There is also the sustained practical work conducted by Andrea Cusumano, the Sicilian artist who has created a series of pieces in recent years with postgraduate students at the University of the Arts in London, all of which have been based on practices taken from Kantor's oeuvre. These have been premiered at the Krzysztofory Gallery in Krakow, Kantor's historic venue, and have been shown in London and Edinburgh. I am therefore indebted to all these artists for sharing with me their procedures.

This chapter therefore relies very much on these accounts of work by Kantor's own company members and on Cusumano's exercises. By examining Kantor's work and combining this with our knowledge of his philosophy and methods, we can therefore supply a series of practical projects and experiences which we might call a Kantorian approach to performance. We can start with some general procedures and follow these with specific exercises.

KANTOR'S REHEARSALS

There is, however, one particular source of information as to Kantor's approach – method is too strong a word – which is the record of rehearsals of his last performances held in the Cricoteka archive in Krakow, mostly now on DVD, showing several of his key procedures. The first was the initial and often protracted discussion of ideas, which typically would be the long-term interests or even obsessions of Kantor himself, such as the function of memory or the use of texts by Witkiewicz. These discussions would often take precedence over any exercises or obvious studio experiment, and would often take up the majority of the rehearsal period.

Kantor himself, in his programme notes to *Let the Artists Die*, wrote the following:

> I have noticed that when I begin to think about creating something new, vari-
> ous things fall into my hands, elements from different domains that seem to be
> accidental, good for nothing, logically unconnected, so that it is impossible to say
> what can be done with them, without any reasonable unity. And yet I feel ... that
> they have shared cause and I get the vague impression that they are guided by
> some hand, some unknown power, that they have some origin.

What emerges is a mixture or *midrash* of images and ideas worked on
in rehearsal that are like a series of brushstrokes on canvas until the
relations are clear and evoke what Kantor wants the spectator to
receive. Given Kantor's life and experiences, it is not surprising that
much if not all of his work is to a greater or lesser degree biographical,
a lot of it experienced by his company of performers.

The second aspect to note, therefore, is the intense relationship
between Kantor and his performers. Since he knew intimately the
character, skills and abilities, and history of every member of his
company, and that many of them were personal friends, he could
simply suggest an idea to an individual and wait and see how he or
she would react, what they would bring to the interpretation, and
what special characteristics he could call on. As we have pointed out
before, Kantor's performers were for him the equivalent of colours
on an artist's palette, to be used as and when commanded or imag-
ined. Rehearsal footage shows the way in which the company would
often originate the images, on the one hand, or would need intense
tuition to realise them, on the other. Therefore any director wishing
to adopt a Kantorian approach needs to find a group of people who
can be persuaded to become welded into a creative force, willing to
share ideas with an open mind. They should have a variety of skills,
and should know each other intimately and be prepared to spend
long hours together working at a visual approach to performance.
Contemporary companies, none of which copy Kantor yet which
work in this collective way, include Forced Entertainment (UK),
Theatre de Complicite (UK), the Wooster Group (USA) and Pina
Bausch (Germany).

The rehearsal process with Kantor, therefore, was much like the
experience of a painter filling his canvas with images, some of which
might be retained, some disregarded, some altered and extended. It
was therefore essentially a process of suggestion and improvisation,
although Kantor loathed that word. The procedure could be described

as collaboration with fellow artists on something arising from a dominant theme, which may have originated with Kantor, but which would be transformed in the rehearsal space. So although we can discern a modus operandi, we can only guess at the ways in which initial ideas were discussed and transformed in rehearsal. What we can observe throughout is the sense of fun that was often engendered by Kantor – there is a lot of laughter in these rehearsal DVDs – even if this was often punctuated by his rages against bureaucracy, against those that did not understand him, against individual performers or technicians – all of whom learned, over the years, to sustain these with good humour, since they knew that they were a necessary part of Kantor's process.

SUGGESTED EXERCISES

Exercise 1: Gallery work 1

Anyone desiring to create work with any kind of Kantor flavour must first learn to look, and above all to acquaint themselves with as much twentieth-century visual art as possible. For a start, get to know intimately the contents of your local museums and art galleries, wherever you live. Most towns and cities in Europe have collections of art on display, so look carefully at your local collection. Pick out half a dozen key images which strike you as being interesting. These may be of people, objects, landscapes, seascapes, in any medium – paint, sculpture, drawing, installation. Using a group of performers, devise a series of still images which utilise what you have seen. Reproduce a picture of people, turn your performers into still objects, photograph the result.

Exercise 2: Gallery work 2

Utilising the same set of procedures, devise the image which you think could follow on from the first – the next stage, next movement, next moment. Get your group to produce this image. Photograph the still result. Repeat until you have run out of sequences. As you progress, analyse the strengths and weaknesses of each still image in terms of their inventiveness. This practice of looking carefully needs sometimes to be learned, particularly if one is trained as an actor in any traditional Stanislavskian sense, since Kantor's theatre, as we know, depends above all on the visual image rather than any psychological root.

Exercise 3: Images at home

Look at what objects you may have in your home. Then start looking at these in new ways and try seeing them as strange works of art – chairs, tables, corkscrews, knives, forks, spoons. Arrange some of them as pieces in an exhibition, giving them new possibilities. What happens to a cheese grater when you make it an object in an exhibition? Arrange and catalogue these objects and invite your friends to the exhibition opening, with drinks and nibbles. Try, in forming your exhibition, to look at creating, for example, a confrontation between a coffee cup and a bottle of wine, or between a pair of scissors and a piano. Learn to invent correspondences between what may seem unlikely objects that lie around the space where you live. Learn to disassociate objects from their usual function and to play with the alternative ways in which they could be seen when placed alongside others. As the American artist, and an admirer of Kantor, Robert Wilson explained, a Colombian statue takes on a new meaning if it is placed on a table beside a tin of baked beans.

The text

It is vital to remember that Kantor's attitude towards performance texts was not unique in twentieth-century theatre practice, in that words were always seen as integral elements alongside found or made objects, scenographic images, costume, sound and the live performer. This approach was taken earlier in the twentieth century by the Dada artists and poets, for whom the word was but one artistic element among many. For the Dadaists the destruction of the word took place in their found poems (where poems were constructed of discarded or chopped-up phrases). There was never any sense in which the text was privileged over other elements, and there was never any sense in which Kantor's approach was one of interpretation. The texts that Kantor used were often plundered for their shape or ideas or sounds, never as material to be respected according to the author's wishes. This is why the texts that Kantor often used tended to be surreal (Witkiewicz) or deliberately illogical (Gombrowicz), or simply autobiographical fragments (*Wielopole, Wielopole*). It was also why critics often found difficulty in categorising what it was that Kantor had produced. Were these 'plays' or art gallery pieces, or total theatre experiences?

Exercise 4: Found texts

Take any text – prose, poem, playtext, letter – and devise from it a set of
visual performance images with your group that either illustrate the text
or deliberately play against it. Try not to interpret the text but to present
visual images which utilise it as a sound element alongside the visual
image. The result may be surreal or chaotic, but never less than interest-
ing. Out of these create a ten-minute sequence of performance material
with a strongly visual base, yet using the words you have chosen.

Space

Most of Kantor's works were shown in non-theatre spaces – the Krzysztofory
Gallery, a medieval cellar in the centre of Krakow, churches, large gymnasia –
rather than in orthodox theatre spaces. There were several reasons for this.
Although he spent much of his life designing sets for theatres in Krakow and
other Polish cities, once he came to form Cricot 2, Kantor saw the group as
essentially being very much outside and in opposition to both the mainstream
of Polish theatre and the communist bureaucracy that was in control of the
country for most of his career. But his theatre, in its attempt to create an
anti-illusionist, non-narrative, non-naturalistic, visually based aesthetic, could
not possibly be presented in spaces where the reception of the performance
was controlled and filtered through an architecture based on nineteenth-
century ideas. Theatres, with their formality, their arrangement of seats in
stalls, circle, balcony, and their social rituals, became anathema to Kantor.

In his essay 'New Theatrical Space' (1980) Kantor analyses reasons
why theatres, with their division into stage and auditorium, were the
least suitable places for the 'process of extending the sphere of Fiction
and Imagination into the sphere of the reality of our lives'. This con-
viction that theatres had somehow betrayed reality lay behind his con-
stant insistence that Cricot 2 should play in 'poor' spaces,
uncontaminated by outdated visions of what theatre should be. It was
ironic that his last show, *Today is My Birthday*, performed all over Europe
after his death in 1990, was mostly given in official theatres – a final
comment on the eventual status of Cricot 2 in world theatre.

Exercise 5: A poor space

Find a non-theatre space – a small room, a gallery, a café, a garden shed
even – and perform Exercise 3 – Images at Home – in the space, no

matter how crowded it may be. Analyse how the spatial arrangements alter or extend the performance material. Examine the audience–performer relationship in such a space. How does the material relate to small numbers of audience?

Objects

As we have seen throughout this book, Kantor intended in his creation and use of invented objects to give these the same status as performers, to give a visual clue to the meaning of the performance by means of their usage and manipulation. Thus, in *The Dead Class*, the school benches become the site for the exploration of memory as well as simply somewhere for the cast to sit; the 'privy' to which various characters retire during the course of the piece becomes a performative element in its own right. The camera of the local photographer in *Wielopole, Wielopole*, becomes a gun and creates for the audience an ambiguous set of visual connections that insert themselves into the performance. In constructing these multiple objects Kantor was always stressing the poverty of the materials that should be used, so that the objects could take their equivalent place on stage with the performers. The object could also be such that the entire piece might proceed from its presence. This was the case with the school desks in *The Dead Class* and with the revolving bed in *Wielopole, Wielopole*. Andrea Cusumano maintains that a Kantor production of *Hamlet*, for example, if it ever existed, might start from the presence of a sword alone.

Exercise 6: Invented objects

Put together a set of old used objects from various sources in a large sculptural design. These could be, for example, a chair, a bicycle, an old door, a brush – anything you come across. Find a way of making them all hang together, noting the possibilities of sound that may occur as you build. When you have finally put the sculpture together, devise a way of making sound a key feature. The objects may clatter or bang or produce a more harmonious sound.

Music

All Kantor's theatre pieces include elements of music taken from the classical repertoire and from specific historical social situations. There are

marches and Roman Catholic/Jewish chants in *Wielopole,Wielopole*, and the Polish waltz in *The Dead Class*; tangos are spread among several of the pieces, as well as military marches reminiscent of Kantor's youth at the end of the Austro-Hungarian Empire. Chopin's piano music is featured in several pieces, as is the Rakoczy March from Berlioz's *The Damnation of Faust* in *I Shall Never Return* and music by Offenbach in *Today is My Birthday*. The choice of music is always very specific and is never used as mere background. Like the objects, music and sound are used as critical elements in the performances, sometimes repeated again and again, sometimes cut short, the volume often being altered by Kantor with a wave of his hand. Music often leaves the audience with a hypnotic memory: for example, I am unable to forget either the Waltz François from *The Dead Class* or the Offenbach march from *Today is My Birthday*.

Exercise 7: Music source

Find a favourite disc or song or live music piece which evokes a past period. Invent a way of making this sound, then add it to any of the results of the previous exercises, creating a five-minute sequence of image, object and sound.

KANTOR'S OWN EXERCISES: *THE MILANO LESSONS*

In the course of *The Milano Lessons*, a project he conducted in June 1986 with eleven students of the Civica Scuola d'Arte Drammatica in Milan, Kantor set several exercises as starting points, as well as touching in his prolonged discussions on his key themes. In his introduction Kantor begins by relating his experience of great art, which he defines as French art, and speaks of his life as being:

> a continual process of discovering things I did not know about. In this sense it has been a process of learning. It has been like a journey during which new lands were discovered and the horizon kept receding – I kept leaving behind me the lands I had just conquered ... artists have to study, discover, and abandon those conquered lands.
> (Kobialka 1993: 208)

Kantor encourages the students, who are in the privileged position of being able to continue learning, to go out and feed their imagination

with the great images of the past. He then emphasises the importance of modern art and the way in which theatre is inclusive: 'Theatre does not have its own single unique source. [Its sources] are in literature, drama, the visual arts, music, and architecture' (Kobialka 1993: 209). This view of course contradicts the ideas of many twentieth-century theatre-makers, such as Stanislavsky, where the creation of character is all important, or Grotowski, for whom theatre was a kind of purgation as a result of performer technique, or the UK mainstream, which maintains that theatre is about the writer handing over a script. Kantor is probably the only major figure of our time to acknowledge the broad range of influences and disciplines that go towards the making of a theatre piece. This attitude throws up the question of what kind of training is most appropriate. Kantor implies, therefore, that training in the physical act of seeing may be the first stage. He then goes on to isolate various visual forms which need our attention.

This exercise allows the student to experiment with certain basic shapes and movement by insisting that the notion of absence is a key concept:

> Abstraction, defined as a radical form, has been a rare phenomenon in theatre. It was fully realized in the Bauhaus in the theatre of Oskar Schlemmer ... the elements of abstraction – that is the square, the triangle, the circle, the cube, the cone, the sphere, the straight line, the point, the concepts of space, tension, and movement – are all elements of drama. They can be defined by philosophical, human, and psychological categories. Each of these [elements], however, has its own [autonomous] essence, its quandary, and its closure. A line [has its] infinity; a circle its repetitiveness; a point its separateness. [These characteristics] constitute the fabric of drama as interestingly as human conditions, conflicts, and misfortunes did in Greek Tragedy.

Exercise 8: An abstract movement

Two people, one in white and another one in black, are on stage. The figure in white walks round in a circle. The figure in black draws a straight line by walking forwards and backwards. The straight line extends from the front to the back of the stage and runs next to the circle. The figures perform actions that are useless in everyday life. Their actions are neither psychologically nor emotionally motivated, but are purely useless. The actions are repeated and can be repeated endlessly. If they are repeated at length the actions will acquire a

stronger physical sense of being and a more precise definition. Test it out and see.

Kantor goes on to define the importance of the object which erupts into this emptiness. Referring to his Underground Theatre in Krakow in 1944, he talks of abstraction having disappeared in Poland during the war as a result of the period of mass genocide, but that objects were things that were grabbed and called works of art. He refers to the objects that arrived on his stage as a result of the war, and that he included in *The Return of Odysseus*:

A cart wheel smeared with mud
A decayed wooden board
A scaffold spattered with plaster
A decrepit loudspeaker rending the air with screeching war announcements

Exercise 9: 'A circle and a line'

One person performs a circle. Another performs something that is in opposition to a circle – that is, a line. Dramatic tension appears and increases when the line gets closer to the circle. When the line passes the circle and moves beyond it the tension decreases. Practise this, increasing and decreasing the time and speed elements.

Exercise 10: 'The object's immobility'

A rectangular box stands in the middle of the stage. A figure in white appears stage left. His walk is mechanical. He approaches the object. He stops in front of it as if further movement were forbidden. He turns around and walks stage left in the same manner. The moment he turns round and begins to walk back, a figure in black appears stage right. He walks in the same manner towards the object. He approaches it exactly at the moment when the white figure disappears stage left. The figure in black turns around and walks back. He disappears. At the same time the white figure appears on stage and begins to walk towards the object.

Kantor talks of the way that tension has similar characteristics as space in that it is created by the network of relationships between characters, their positioning of hands, legs, the whole body, and by the distances that grow and decrease between figures. Often we can see the emphasis on tension by the way that Kantor places figures on stage in his theatre pieces.

Exercise 11: A person and a shadow 1

A performer is standing in the middle of a theatre space. He is motionless. The light moves around. The light is directed at him from various directions and heights. The shadow keeps changing. At one time it is very long and thin; at other times it is very short and obese. It shrinks or expands. Observe the way in which the character of the light changes.

Exercise 12: A person and a shadow 2

A second performer lies on the floor and plays the part of a shadow of a standing person. The performer who is standing moves, respectively, his hands, his legs, his head and his whole body. The other actor mirrors the movements; he repeats the movements in the horizontal position of a shadow. A third actor lies on the floor and becomes the standing person's second shadow. Now a fourth actor joins them. There are three shadows on the floor. The standing actor repeats his movements for each of the three actor-shadows on the floor. His movement becomes quicker and quicker until he merges with them so that they become one inseparable unit.

Exercise 13: The wedding ceremony

The action follows the protocol of a religious ceremony, using appropriate rituals. The wedding procession is formed on a slanted platform on stage. The bride is pushed into a wheelbarrow – an iron splattered with plaster. This act is full of malice. The bridegroom is left behind. He has been forgotten. The bridegroom's mother is weeping. She does not move away from her chair. Its construction is so complex that every time the weeping mother wants to sit on it, the chair collapses. Of course, each time it happens, the mother falls down and begins to sob. This sobbing, associated with the act of falling down, 'counteracts' another sobbing – that is, the mother's sob at the wedding ceremonies of her children. The bride's sister is jumping through a hoop and is singing lalala . . . lalala . . . lalala A sacristan is pulling a rope that, rather than being connected to the church bells, leads to a bicycle wheel and functions as a conveyor belt. Yet the tolling of bells is heard. The bishop is conducting this dual ceremony.

CRICOT 2 ACTORS' EXERCISES

Andrejz Welminski

Welminski is one of the longest-standing members of the Cricot 2 group, having appeared in most of Kantor's performances right up to the end. He is a painter himself and exhibits regularly in Poland and abroad. He also leads workshops on Kantor's work, emphasising that there was no Kantor 'method' but a series of common concerns and questions asked that led him to create his work. Welminski emphasises that students or would-be artists who wish to use Kantor's elements must have a deep visual appreciation and a sense of creativity. They must not expect starring roles, but to be part of a creative ensemble. He talks about Kantor's interest in memory – what we remember, how we remember, how we can convert memory into theatre. He points out that, when the company was creating *Wielopole, Wielopole*, Kantor would share his family memories with them. He tells me that Kantor emphasised the partiality of memory: he does not remember his father's face, for example, but only his army boots. He remembers his aunt's colour, nothing more. The priest's bed is remembered only by his feet sticking out at the bottom. In this way the objects remembered helped create the show.

Exercise 14: Memory

Try to remember aspects of your own childhood – games, parents, friends, images. You may, for example, remember a light from a window, or your mother standing against an open window, and so on. What, then, can be made of this memory – what event, or image, or even what kind of object could be constructed from the memory? And from these elements can be created a piece of visual theatre which follows a sequence of such memories.

Exercise 15: Old master

Take a famous picture of which you may have a reproduction at home and use its shape or visual frame or activity as a starting point. Kantor, among other paintings, used Velásquez's *Las meninas*, Géricault's *Raft of the Medusa*, Leonardo's *Last Supper*, Repin's *The Barge Haulers* and others. Take from the painting you have chosen the following possibilities – poses, faces, attitudes, costumes – and construct a sequence utilising these elements.

Ludmila Ryba

Ryba joined Cricot 2 for *Wielopole,Wielopole* and played in most perform-ances after that – *Let the Artists Die*, *I Shall Never Return* and *Today is My Birthday*. She also maintains that there was no 'method', merely a series of procedures, or what she calls 'Kantorian rules'. There were general concerns such as the relationship between the actor and the space, the collectivity of the creative process, the lack of any correspondence between the actor and the text. The work was never about interpretation or any psychological way of playing. Stanislavsky was 'out of the window'.

Exercise 16: Objects

Make a sketch of an object, or find a real object, then tell its story, put-ting yourself 'behind the object', so that it is in no way a 'prop' but becomes the central performative element in your invented visual story.

Exercise 17: Text

Take a textual extract from anywhere, learn it absolutely, and to speak it with no context, no interpretation. Add to it a series of such texts by indi-vidual performers, then from these vocal moments a surreal series of sequences will emerge.

Marie Vayssière

Vayssière is a French actor and director who joined Cricot 2 in the last few years of Kantor's life and who took part in the final piece, *Today is My Birthday*, where she played the character of a lost art student who appears one day at Kantor's archive.

Exercise 18: Objects/text

Take any object to hand and play with it, telling stories, creating histo-ries, shapes, confrontations. Next take some little pieces of text and repeat them again and again, to see how the text can be used as an object. Create a series of text/object events and performances, none of which should be more than five minutes in length.

ANDREA CUSUMANO'S EXERCISES

Cusumano is a Sicilian artist who, for the past few years, has been working at Central St Martins (University of the Arts, London) developing a series

of Kantor-inspired performances. These have all been premiered at the Krzysztofory Gallery in Krakow – Kantor's own space – and then been shown in London and at the Edinburgh Fringe. He has used Myra Rychlicka, one of Kantor's Cricot 2 performers (who sadly died in 2008), who was able to give him a unique insight into the Kantor experience. Cusumano aims to create works with a Kantor aesthetic, and in so doing has devised a series of exercises which might form the basis for work by students.

Exercise 19: Creative function of objects

Collect a series of found objects in your environment. Choose them without a specific goal; let each object inspire you for its texture, aesthetic or mechanical quality. Do not plan any plot or performance. The object you choose is not a prop. Once you have collected the objects, divide them into several categories (for example, written text, windows, iron, wood, tools, toys). Let each member of the group choose one object and start to play with it in the same room. Find an original way to use it; avoid using the object in the way it is supposed to function. Once everybody has warmed up, start to create links between the different objects/performers. Keep using the objects and their function as the main meaning-making factor. Stop the experiment once all the objects/performers have interacted with one another.

Exercise 20: Objects as score

Choose one object which has a particular meaning in your life (a picture, a letter, a present). Try to remember the situation to which this object is related. Once you have brought back the memories attached to the object (the situation pictured or told), try to portray on stage the entire situation. Re-imagine the environment, the characters, and the relationship between the characters. Starting from this setting, improvise a possible narrative development. (Another option is to start from the empty stage and, step by step, build the picture, constructing it as a choreography and a rhythm of movements.)

Exercise 21: Object as character

Choose an existing narrative (it could be a book, a fairy-tale, a real story or a theatre plot). Define some of the characters of the story and discuss with the group which qualities of the characters you intend to employ.

Transform the quality of each character into a function (Example 1: A young seductive woman = seduction; 2: A dreamy/mad old man/woman = flying; 3: A meticulous and compulsive notary = reading).

Create an image with objects, which will express the function you have identified (Example 1: A cardboard box with some windows from which, from time to time, the character can show parts of her body; 2: Large wings and a structure where the actor could be suspended; 3: A table and some books attached to the body of the actor).

Let the actors interact with their costume/prop, creating a series of repetitive actions.

Create a short visual performance according to the original plot.

Exercise 22: Site specific

The space as a dramaturgical force is evident in Kantor's work. In his early Happenings and in performances such as *Lovelies and Dowdies* or *Water-Hen* the site-specific quality of the space was considered a decisive factor of the piece. In order to experiment with this aspect, choose an existing space, which could be an abandoned hangar, an old school, or a church. Invent a story related to the space (identify the function of the rooms, the characters that were living there, what their activities were, and so on). Once you have defined your story in the space, start to build the set, creating the mood according to the elements already existing in the space. Using the existing objects found in the space, transform and re-imagine them. Having now the set and the story, you can opt for an installation or an installation performance, which is describing/performing your story.

Exercise 23: The function of space

Choose an existing narrative from a book or a story. Identify the different sets/spaces in which the story should take place. Analyse the functional quality of each set according to the story.

Example: 1 Story: *Little Red Riding Hood*. 2 Sets: a) Little Red Riding Hood's House; b) The forest; c) Grandma's House. 3 Functions: a) A safe place from which everything starts; b) A journey, full of unknown situations; c) An apparently safe place but where the appearance is different from the reality.

Re-create in a black box the function of each place and the relationship between them without paying attention to the narrative elements.

For example, the entrance to the black box represents the limit between the safe space and the unknown situation. In the black box there is a tortuous labyrinth of corridors that are leading to different exits. At the end of each corridor there is a room. In one of these rooms you are invited to sit down for dinner. Everything looks quite comfortable and friendly, but during the dinner . . .

Exercise 24: Space as a score

Occupy a large room. With wood and paper start to build a series of spaces (rooms, corridors, windows, doors, and so on). Do not plan the architecture of the space in advance but let it come out from the physical work. Once the space is completed, start to interpret the way it could work, from the point of view of both the performers and the audience. Choose a narrative from a book and divide it into units of action. Try to fit each unit in each space, creating a pathway for the narrative.

CONCLUSION

The interest in Tadeusz Kantor's work and his creative practice has increased since his death in 1990, for which there are several reasons. First is the invaluable presence in Krakow of the Cricoteka archive, housed in several locations. Then there are the high quality DVDs with English subtitles, particularly the films of Andrejz Sapija, which are slowly coming onto the market. There are the two books in English, by Plesniarowicz and Kolbialka, which guide us through the life and mind of the artist. This means that, together with the archived evidence, we can come closer to the creative practice of the artist, and thereby suggest methods to interested students and practitioners. Then there has been the growing interest in Kantor's art by students and practitioners who see the links between painting and theatre. In both the UK and the United States there has grown up a following in certain universities where Kantor is recognised as a key twentieth-century figure who has influenced major artists such as Robert Wilson. Finally there has been the major attempt, by Hans-Thies Lehmann in his book *Postdramatic Theatre*, to locate the stream of later theatre-makers who have become aware of Kantor's work. All this means that Kantor is now seen as an essential representative of theatre as both a visual art and a repository of historical and personal memory.

Sites in Krakow relating to Tadeusz Kantor (1915–1990)

Rynek Główny 22 (Main Square)
In December 1965, in the then headquarters of the Art Historians Society, Kantor made his first Krakow Happening, *Demarcation Line*.

Rynek Główny 27 (Main Square)
In 1949, in the surroundings of the historical courtyard of the Pod Baranami Palace, Kantor, together with Maria Jarema, prepared a theatre version of Neruda's *Let the Rail Splitter Awake*.

Rynek Główny 35 (Kraków Historical Museum)
In July 1957, the first individual exhibition of Kantor's painting in Krakow, spanning the years 1948–57, took place in the vestibule of the Krzysztofory Palace. Nearly half of the works were Tachiste paintings from the previous two years, and they were partly created in the Stary Theatre stage design workshop located in ulica Rajska.

2 ulica Szczepanska (now also housing the offices of the Cricoteka)
The Krzysztofory Gallery was the location of the Krakow Group Artistic Association from 1958 to 1980 and of Cricot 2, as well as the venue for rehearsals and performances (premieres of *In a Little Manor House*, *The Madman and the Nun*, *The Water-Hen*, *Lovelies and Dowdies*, *The Dead Class*).

1 ulica Jagiellonska (Stary Theatre / Old Theatre)

Kantor made his professional debut as a stage designer in the Stary Theatre, where he was subsequently employed from 1954 to 1961 and where he created over twenty stage designs between 1951 and 1962. From 1957 to 1961 he lived and worked in his atelier in the attic of the theatre, which is where the Krakow premiere of *I Shall Never Return* took place in 1990.

4 plac Szczepanski (Palac Sztuki / Art Palace)

In 1946 Palac Sztuki housed the Young Artists Group exhibition organised by Kantor, and two years later hosted a major national modern art exhibition which he had initiated and organised. In 1962 he presented here a posthumous exhibition of the works of Maria Jarema (1908–1958).

21 ulica Szewska

Clandestine performances took place in Ewa Siedlecka's apartment here in 1943 of J. Słowacki's *Balladyna* by the Clandestine Independent Theatre, directed by Kantor.

23 ulica Sławkowska

The location of a small 'U Warszawianek' café which Kantor used to visit in the 1940s and 1950s.

1 plac Ducha (Słowacki Theatre and Opera House)

From 1937 to 1939 Kantor frequented the Słowacki Theatre professionally, as a student of Professor Karol Frycz, its director. During the war the theatre was renamed Staatstheater des General Governments, and from 1943 to its closure in October 1944 Kantor was a member of the technical team. After the war, in 1945, he created stage designs for several plays and in the 1950s for *The Mayor of Zalamea*, by Pedro Calderón de la Barca. In January 1986 the theatre hosted the Krakow premiere of *Let the Artists Die*.

7 ulica Sienna, apartment 5

From July 1987 until his death Kantor lived in this flat, which is now open to the public. It is currently a gallery / workshop and part of the Cricoteka.

5 ulica Kanonicza

The home of the Cricoteka archives. From January 1980 it was the Cricot 2 Theatre Centre, where Kantor inaugurated the activities of the Cricoteka with an exhibition, *Cricot 2 Theatre Ideas*.

Wawel (Royal Castle)

In the space of Wawel's courtyard, in August 1939, just before the outbreak of the Second World War, Kantor helped Karol Frycz to prepare the decorations for Morstin's *Anthem in Honour of Polish Arms* – a show organised to commemorate the twenty-fifth anniversary of the Legion's departure from Krakow.

1 ulica Oleandry (Rotunda Club)

On 2 August 1945, in the Rotunda Club (formerly the auditorium of the Second Dormitory of the Jagiellonian University), Kantor and the Academic Theatre Group staged Czechowicz's morality play *The Unworthy and the Worthy*, for which he prepared the costumes and decorations. The performance was a continuation of his experimental theatre from the war period. From 19 to 24 November 1978 the Rotunda Students' Club was the rehearsal venue for *The Dead Class*.

3 ulica Humberta (the Faculty of Interior Design and the Faculty of Graphic Arts of the Academy of Fine Arts)

Until the early 1950s the building housed the Higher School of Fine Arts, where Kantor started his teaching career as a professor of painting after his return from Paris in the summer of 1947. He was dismissed from this post in the mid-1950s.

27 ulica J. Piłsudskiego (Polish Gymnastic Association – Sokół)

The Sokół Hall hosted Cricot 2 Theatre's performances of *The Dead Class* (May 1983), *Wielopole, Wielopole* (November 1980, December 1983) and *Today is My Birthday* (May 1991).

21 ulica J. Piłsudskiego

Formerly Wolska Street. The location of the Mehoffer Private Independent School of Painting and Drawing (headed by Zbigniew Pronaszko), which Kantor attended for a year before taking up his studies in the Academy of Fine Arts in 1934.

18 ulica Piłsudskiego

In March and April 1944 a building formerly called 'Puszetówka', owned by the Puget family, served as a venue for the rehearsals of Wyspianski's *The Return of Odysseus*, which Kantor directed with the Independent Clandestine Theatre.

3 ulica Grabowskiego

The house where, in June 1944, Kantor produced Wyspianski's *The Return of Odysseus* with the Independent Clandestine Theatre.

6 ulica Siemienskiego

Before the war on a side-street, 103 Kazimierza Wielkiego. The house where Kantor lived from 1938 to 1942, and where he received the telegram from Auschwitz on 1 April 1942 notifying him of his father's death.

3 ulica Łobzowska Street (Dom Plastyków / Artists' House)

The location of the premiere of Witkiewicz's *The Cuttlefish* (1956) directed by Kantor as the official inauguration of Cricot 2 Theatre.

11 ulica w. Filipa

The house in which Kantor lived from 1945 until the late 1950s, and in 1942 the cradle of his Clandestine Independent Theatre.

3 ulica Kurniki

The stage design and mural painting workshop of Professor Karol Frycz, who was mentor to Kantor from 1937 to 1939. Some of the classes took place at 7 ulica Warszawska.

13 plac Matejki (Academy of Fine Arts)

Kantor studied at the academy from 1934 to 1939. The year 1937 saw the origins of his marionette theatre and the staging of Maeterlinck's play *The Death of Tintagiles*. In 1967 Kantor accepted the post of associate professor at the Faculty of Painting and Graphic Arts, which he held for two years.

ulica Rakowicka (Rakowicki cemetery)

Kantor was buried next to his mother (location LXXII–35–9) on 14 December 1990. His sculpture *A Boy at a Desk* is placed on his tomb.

17 ulica Arianska

During the war – in 1942 – in Tadeusz Brzozowski's flat, Kantor prepared the staging of Cocteau's *Orpheus* for the Independent Clandestine Theatre.

18 ulica Kupa (Isaac's Synagogue)
After its annexation by the Germans as a Staatstheater stage design workshop, Kantor worked there in 1943–4 as a *Dekorationsmaler*.

10 ulica Wegierska
The house near the Jewish ghetto where Kantor lived from 1942 to 1945. It is here that he created his sketches and ideas for his wartime performances: Słowacki's *Balladyna* (1943) and Wyspianski's *The Return of Odysseus* (1944).

GLOSSARY OF NAMES AND TERMS

Auschwitz (Ozwiecim) The most notorious of the Nazi concentration and extermination camps established by the Germans during the Second World War, sited at a key railway junction 60 kilometers west of Krakow. It is today still a harrowing document of one of Europe's most shameful periods.

Austro-Hungarian Empire The name given to the empire of the Habsburgs from 1887 to 1918. Its capital was Vienna and it was geographically the second largest country in Europe after the Russian Empire, being a union of Austria and Hungary after Austria's defeat in the war of 1866. It contained numerous minorities, including Czechs, Poles and Romanians, and it was the dissatisfaction of the southern Slavs which led to the assassination in 1914 of Franz Ferdinand, the heir to the emperor, Franz Joseph, and thus to the First World War.

Bauhaus The famous German school of Art and Design, founded in 1919 and closed down by the Nazis in 1933. It left its influence on art, design and performance education across Europe and was directed by Walter Gropius with, among others, teachers of the calibre of Paul Klee, Wassily Kandinsky and Oscar Schlemmer.

Bausch, Pina (1940–2009) German choreographer and director of the Wuppertal Dance Theatre. She creates dance theatre work that utilises the attributes of her company often as autobiographical elements in intense performances such as *Café Muller* (1978), *A Piece by Pina Bausch* (1980) and *Kontakthof* (1978). Bausch's rehearsal methods approximate to Kantor's in that the performers' own skills become the elements of the images which she creates and develops to a great intensity.

Beckett, Samuel (1906–1989) Irish dramatist, resident in Paris for much of his life, whose theatre pieces, especially in his later years, present us with strong imagery and total performance texts, with strict directions. These plays – *Not I*, *Quad* and *Ohio Impromptu*, for example – are extraordinary in their visual scope and in the notions of theatre that they propose, being nearer to installations than to conventional playtexts.

Brook, Peter (1925–) British director and theatre-maker, once connected with the Royal Shakespeare Company, now based in Paris, whose work has always been seen as a major experimental force in Europe. His productions include a trailblazing *Midsummer Night's Dream* (1970), *Orghast in Persepolis* (1973) and *The Mahabharata*, a lengthy adaptation of the Indian epic poem. Over the years his Paris theatre, the Bouffes du Nord, has become a centre for his continued work with his International Centre for Performance Research.

Cage, John (1912–1993) American composer and philosopher whose music investigates and questions assumptions about sound and listening. His most famous composition, *4' 33"*, offers the listener a silent piano, the 'music' being provided by the ambient sounds around it, and in 1946 he wrote *Theatre Piece*, which allows the performers to compose their own scenario within prescribed time limits, using chance techniques.

Communism The system first proposed by Karl Marx, in *Das Kapital* (1867), whereby the proletariat, or working class, would dictate political life. However, the Russian version was responsible for utopian social experiments as well as the ruthless elimination of those who did not toe the party line: many artists and intellectuals were sent to Stalin's gulags in Siberia.

Constructivism An artistic and architectural movement initiated in Russia around the time of the First World War (particularly notable after the October Revolution) which dismissed 'pure' art in favour of an art used as a practical instrument for social when it was replaced by Socialist Realism.

Craig, Edward Gordon (1872–1966) British theatre designer, theorist and visionary, whose life was full of unresolved schemes for designs and performances. In 1911 he published *On the Art of the Theatre*, in which his theory of the Uber-Marionette proposed that, if the theatre is to move beyond the natural, the actor needs to take on the attributes of a puppet.

Dada A movement of artists gathered in Zurich during the First World War, whose most famous manifestation was the founding of the Cabaret Voltaire, where their anarchic performance manifestations expressed their disgust at the beliefs which had caused the war. Tristan Tzara was one of the principal members, who consisted of writers, painters and musicians; the sound poet Kurt Schwitters was a later follower.

Demarco, Richard Impresario and owner of the Demarco Gallery in Edinburgh (which later became the Demarco European Art Foundation) and the first person to introduce the work of Kantor to UK audiences, in 1972. Demarco went on to present the work of other Eastern European artists throughout the communist period and was responsible for introducing Kantor to the German artist Joseph Beuys.

Forced Entertainment UK company, directed by Tim Etchells, founded in 1984 and responsible for some of the most challenging theatrical responses to the urban experiences of its audiences, including the effects of the mediatisation of culture and the issues and problems of cultural identity. Among their most significant productions have been *Emmanuelle Enchanted* (1992), *Club of No Regrets* (1993/4), *Speak Bitterness* (1995) and *Quizoola* (1995).

Gombrowicz, Witold (1903–1969) The third of Kantor's major literary sources was born in Warsaw. He was born into a wealthy family, and in 1939 went on the maiden voyage of a Polish cruise ship to Argentina, where he stayed through the Second World War. He returned

to Europe only in the 1960s, finally settling in the South of France. Among Gombrowicz's novels are *Pornographia* (1960), *Trans-Atlantic* (1980), *The Possessed* (1980) and *Cosmos* (1967), and he wrote three plays – *Princess Ivona*, *The Marriage* and *Operetta*. His novel *Ferdydurke*, which Kantor used for parts of *The Dead Class*, was published in 1937, but gained a scandalous reputation as well as being banned under the communist regime. In 1958 Gombrowicz vanished from publishers' lists in Poland, but a French edition of *Ferdydurke* appeared in 1958, when it was described as a 'strange masterpiece'. Kantor takes some images and a few words from the book, and sees it has having the same illogical strain and school ethos as *The Dead Class*.

Kaprow, Allan (1927–) American artist, founder of the so-called Happening movement in the early 1960s. Around 1956 he began making what he called Assemblages, which used found material from the surrounding environment, and creating Environments and Happenings, from which his influence spread through much contemporary art and performance. 'It is important', he wrote, 'to declare as art the total event comprising noise/object/movement/colour and psychology.'

Katyn In April 1943, 4,321 corpses of Polish officers were found in the Katyn Forest, on the banks of the Dnieper, near Smolensk. It has now been established that the officers were taken into Soviet detention in 1939, sent to camps and killed on the authority of Stalin. They were intellectuals who were the 'cream of the class enemy' (Norman Davies).

Krakow Poland's second city, situated in the south of the country near the Tatra Mountains, with its many theatres, galleries and flourishing contemporary music scene, has always been considered the intellectual and artistic capital. It is today a thriving place with its many old buildings and cellars turned into clubs and galleries, especially in the Main Square, where the Renaiassance *sukiennice* stands.

Meyerhold, Vsevolod (1874–1940) One of the great pioneering Russian artists who worked with Stanislavsky in Moscow, becoming probably one of the most prolific theatre directors in history, experimenting with both form and the training of actors. In so doing he redefined the possibilities for theatre in the twentieth century. Kantor saw him as an exemplar of all that was worth preserving in mainstream

theatre. Eventually, however, Meyerhold's restless experimentation meant that he fell foul of Stalin, and he was shot in 1940.

Odysseus In Greek legend, the warrior who sailed with the Greeks against Troy, which was besieged for ten years. He outwitted the Cyclops and escaped the song of the sirens by filling the ears of his companions with wax. It was another ten years before he returned after the fall of Troy.

Russian Revolution After the First World War (1914–18) the Russian government was overthrown by a communist revolution, led by Lenin. This cataclysmic event had repercussions all over the world, especially in Western Europe, where politics had to find a new way of confronting intense and often violent idealism.

Schindler, Oscar (1908–1974) A German industrialist credited with saving almost 1,200 Jews during the Holocaust by having them work in his enamelware and ammunitions factories, located in Poland and the Czech Republic respectively. He was the subject of the book *Schindler's Ark*, by Thomas Keneally, and the film based on it, *Schindler's List*, directed by Steven Spielberg.

Schlemmer, Oscar (1888–1943) A painter, choreographer, dancer, theorist and teacher who was one of the major figures teaching at the Bauhaus, where he ran the Stage Workshop. He created a number of experimental stage works that became key reference points for Kantor, of which the most important was *The Triadic Ballet*.

Schulz, Bruno (1892–1942) Schulz is another marginalised Polish writer who was also an artist. He was born in Drohobycz in Galicia (now Ukraine). His father kept a dry goods shop, and for most of his life Schulz taught art in the local high school. He published only two books of stories – *The Street of Crocodiles* (1934) and *Sanatorium under the Sign of the Hour Glass* (1937) – but several books of drawings, among them *The Book of Idolatry* (1924). He also made a translation of Kafka's *The Trial*. Schulz is now considered one of the greatest Polish authors of the twentieth century, with a particular obsessive and offbeat style of writing which has led to his being described by John Updike as 'one of the great transmogrifiers of the world into words'. His stories show a strange but comic

world of a small Polish town brought to life in a unique way. Together with the other Jews of Drohobycz, he was confined to a ghetto during the Second World War, but one day he ventured with a special pass to the 'Aryan' quarter of the city and was recognised by a Gestapo man, who shot him dead in the street. Schulz's work has been brought to wider attention by the publication in English of his stories, by Kantor's tours of *The Dead Class*, and by the work of the London-based theatre company Theatre de Complicite. Kantor took the image of an old person returning to school from Schulz's story *The Pensioner*.

Theatre de Complicite UK company, founded in 1983 by Simon McBurney, Annabel Arden, and Marcello Magni, which is famous for its adaptations of writings and short stories. It has created more than thirty productions, including *Streets of Crocodiles*, based on the writings of Bruno Schulz, *The Three Lives of Lucy Cabrol*, after John Berger's study of French peasant life, and a project about *Shostakovich* alongside the Emerson String Quartet.

Treaty of Versailles The peace treaty that was signed at the end of the First World War in 1919 by the representatives of the Allied powers and Germany at the palace of Versailles near Paris. Under the treaty Germany lost parts of its territory to France and the new Polish Republic; the Austro-Hungarian Empire was dismembered; independence was given to Hungary, Yugoslavia and Czechoslovakia; and the Baltic republics of Finland, Latvia and Lithuania were established. At the same time the League of Nations was set up.

Witkiewicz, Stanisław Ignacy (1885–1939) Polish playwright and artist who wrote thirty plays, only eleven of which were performed during his lifetime. Born in Czarist-ruled Warsaw, he was for the most part considered a joker by his contemporaries. He wrote three books on aesthetic questions, the most important of which is *An Introduction to the Theory of Pure Form in the Theatre* (1923), in which he proposed the need for a kind of theatre which would not seek to imitate life, but would manipulate theatrical elements – image, word, sound, etc. – for purely formal ends, as in painting or music. In this way his ideas approached those of Kantor, who began directing Witkiewicz's plays in 1956 with the first postwar production of *The Cuttlefish*, followed by *In a Small Country House* (1961), *The Madman and the Nun* (1963), *The Water-Hen*

(1967) and *Dainty Shapes and Hairy Apes* (1973). These last two were shown at the Edinburgh Festival Fringe. Witkiewcz called his plays 'comedies with corpses', and they can be seen alongside the work of Strindberg, Jarry, Artaud and the Surrealists, hence his attraction for Kantor. Shortly before the Second World War he committed suicide in Zakopane, near Krakow, and it was not until the1950s that his work began again to be seen as important for Polish culture. But by that time the country was under communist rule and the chances of any official rehabilitation were nil. Kantor clearly saw Witkiewicz in many ways as his mentor, something that is clear in the text of *The Dead Class*, much of which is taken from moments in Witkiewicz's play *Tumor Brainiowicz*, published in 1920.

Wooster Group Founded in New York in 1976 and directed by Elizabeth LeCompte, it is one of the longest established alternative performance companies. It has redefined the positions of the 'performer' and the 'role' and the function of previously written playtexts, which often form the basis for explorations by the group. Creations such as *Route 1 and 9 (The Last Act)* (1981), *LSD ... Just the High Points* (1984), *Brace up* (1991) and *House Lights* (2000) subvert narrative and textual logic, producing technologically brilliant performance variations.

Wyspianski, Stanisław (1869–1907) The great Polish neo-romantic painter, playwright and architect whose work is seen as the foundation of modern Polish drama. The range of his artistic achievements can be seen in the museum dedicated to his memory in Krakow. His work influenced Kantor even up to his last production *Today is My Birthday*.

BIBLIOGRAPHY

BOOKS AND JOURNALS

Beckett, Samuel (1984) *Collected Shorter Plays*. London: Faber & Faber.

Cage, John (1987) *Silence: Lectures and Writings*. London: Marion Boyars.

Cioffi, Kathleen M. (1996) *Alternative Theatre in Poland, 1954–1989*. Amsterdam: Harwood Academic.

Craig, Edward Gordon ([1911] 1956) *On the Art of the Theatre*. London: Heinemann.

Crampton, Richard, and Crampton, Ben (1996) *Atlas of Eastern Europe in the Twentieth Century*. London: Routledge.

Davies, Norman (2005) *God's Playground: A History of Poland*, Vol. 2. Oxford: Oxford University Press.

Drozdowski, Bohdan (ed.) (1979) *Twentieth Century Polish Theatre*. London: John Calder.

Ficowski, Jerzy (ed.) (1990) *Letters and Drawings of Bruno Schulz*. New York: Fromm.

Fiedler, Jeannine, and Feierabend, Peter (eds) (1999) *Bauhaus*. Cologne: Konemann.

Goldberg, RoseLee (1979) *Performance Art: From Futurism to the Present*. London: Thames & Hudson.

Gombrowicz, Witold (1979) *Ferdydurke*. London: Marion Boyars.

Gropius, Walter, and Wensinger, Arthur S. (ed.) (1961) *The Theatre of the Bauhaus*. Middleton, CT: Weslyan University Press.

Grotowski, Jerzy (1969) *Towards a Poor Theatre*. London: Methuen.

Halczak, Anna (ed.) (1986) *Cricot 2 Theatre Information Guide*. Krakow: Cricoteka.

Halczak, Anna (ed.) (1988) *Cricot 2 Theatre Information Guide 1987–1988*. Krakow: Cricoteka.

Halczak, Anna (ed.) (c.1990) *Teatr Cricot 2 Informator 1989–1990*. Krakow: Cricoteka.

Hughes, Robert (1980) *The Shock of the New: Art and the Century of Change*. London: BBC Books.

Hunt, Albert, and Reeves, Geoffrey (1995) *Peter Brook*. Cambridge: Cambridge University Press.

Huxley, Michael, and Witts, Noel (eds) (2002) *The Twentieth Century Performance Reader*. London: Routledge.

Innes, Christopher (1998) *Edward Gordon Craig: A Vision of Theatre*. Amsterdam: Harwood Academic.

Kantor, Tadeusz (1990) *Wielopole, Wielopole: An Exercise in Theatre*. London: Marion Boyars.

Kaprow, Allan (1966) *Assemblages, Environments and Happenings*. New York: Harry N. Abrams.

Keneally, Thomas (1982) *Schindler's Ark*. London: Hodder & Stoughton.

Kobialka, Michal (ed.) (1993) *A Journey through Other Spaces*. Berkeley: University of Cailfornia Press.

Kobialka, Michal (2000) 'Of the Memory of a Human Unhoused in Being', in Adrian Heathfield and Andrew Quick (eds), *On Memory* (*Performance Research*, 5/3). London: Routledge.

Kobialka, Michal (2009) *Further on Nothing, Tadeusz Kantor's Theatre*. Minneapolis: University of Minnesota Press.

Lehmann, Hans-Thies (2006) *Postdramatic Theatre*, trans. Karen Jürs-Munby. London: Routledge.

Micinska, Anna (1990) *Stanislaw Ignacy Witkiewicz: Life and Work*. Warsaw: Interpress.

Miklaszewski, Krzysztof (2002) *Encounters with Tadeusz Kantor*. London: Routledge.

Miłosz, Czesław (1981) *Native Realm: A Search for Self Definition*. London: Sidgwick & Jackson.

Musial, Grzegorz (ed.) (2004) *Tadeusz Kantor: Umarła klasa*. Warsaw: Panstowa Galeria Stuki.

Pioro, Anna (2005) *The Cracow Ghetto 1941–43*. Kracow: Historical Museum of the City of Kracow.

Pirie, Donald, Young, Yekaerina, and Carrell, Christopher (eds) (1990) *Polish Realities*. Glasgow: Third Eye Centre.

Pitches, Jonathan (2003) *Vsevolod Meyerhold*. London: Routledge.

Plesniarowicz, Krzysztof (ed.) (1994) *The Return of Odysseus*. Krakow: Cricoteka.

Plesniarowicz, Krzysztof ([1994] 2001) *The Dead Memory Machine: Tadeusz Kantor's Theatre of Death*, trans. William Brand. Aberystwyth: Black Mountain Press.

Schenkelbach, Erwin (2001) *Behind the Scenes of the Dead Class*. Krakow: Cricoteka.

Schulz, Bruno (1963) *The Fictions of Bruno Schulz*. London: McGibbon & Kee.

Suchan, Jaroslaw, and Swica, Marek (2005) *Tadeusz Kantor: Interior of Imagination*. Warsaw and Kracow: Zacheta National Gallery of Art and Cricoteka.

Whitford, Frank (1984) *Bauhaus*. London: Thames & Hudson.

Witkiewicz, Stanisław Ignacy (2004) *Seven Plays*, ed. and trans. Daniel Gerould. New York: Martin E. Segal Theatre Center.

DVDS

Bablet, Denis (1991) *The Theatre of Tadeusz Kantor*. Chicago: Facets Video.

Sapija, Andrejz (1984) *Wielopole, Wielopole*. Krakow: Cricoteka.

Sapija, Andrejz (1992) *Proby tylko proby* (Rehearsals for 'Today is My Birthday'). Krakow: Cricoteka.

Sapija, Andrejz (2006) *Gdzie sa niegdysiejsze sniegi* (Ou sont les neiges d'antan?). Krakow: Cricoteka.

Sapija, Andrejz (2006) *Powrot Odysa; Nigdy tu juz nie powroce* (Return of Odysseus; I Shall Never Return). Krakow: Cricoteka.

Wajda, Andrejz (1976) *Umarła klasa* (The Dead Class). Krakow: Cricoteka.

WEBSITE

The official website of the Kantor documentation centre in Krakow is www.cricoteka.com.pl

INDEX

Related titles from Routledge

Marina Abramović
Routledge Performance Practitioners series
Mary Richards

All books in the **Routledge Performance Practitioners** series
are carefully designed to enable the reader to understand the work
of a key practitioner. They provide the first step towards critical
understanding and a springboard for further study for students on
twentieth-century performance, contemporary theatre and theatre
history courses.

Marina Abramović is the creator of pioneering performance art
which transcends the form's provocative origins. Her visceral and
extreme performances have tested the limits of both body and
mind, communicating with audiences worldwide on a personal and
political level.

This book combines:

- a biography, setting out the contexts of Abramović's work
- an examination of the artist through her writings, interviews
 and influences a detailed
- analysis of her work, including studies of the *Rhythm* series,
 Nightsea Crossing and *The House with the Ocean View*
- practical explorations of the performances and their origins.

ISBN13: 978–0–415–43207–8 (hbk)
ISBN13: 978–0–415–43208–5 (pbk)
ISBN13: 978–0–203–87065–5 (ebk)

Available at all good bookshops
For ordering and further information please visit:
www.routledge.com

Related titles from Routledge

Robert Lepage
Routledge Performance Practitioners series
Aleksandar Saša Dundjerović

All books in the **Routledge Performance Practitioners** series
are carefully designed to enable the reader to understand the work
of a key practitioner. They provide the first step towards critical
understanding and a springboard for further study for students on
twentieth-century performance, contemporary theatre and theatre
history courses.

Robert Lepage is one of Canada's most foremost playwrights and
directors. His company, *Ex Machina*, has toured to international
acclaim and he has leant his talents to areas as diverse as opera,
concert tours, acting and installation art. His most celebrated work
blends acute personal narratives with bold global themes.

This is the first book to combine:

- an overview of the key phases in Lepage's life and career
- an examination of the key questions pertinent to his work
- a discussion of *The Dragons Trilogy* as a paradigm of his working
 methods
- a variety of practical exercises designed to give an insight into
 Lepage's creative process.

ISBN13: 978–0–415–37519–1 (hbk)
ISBN13: 978–0–415–37520–7 (pbk)
ISBN13: 978–0–203–09897–4 (ebk)

Available at all good bookshops
For ordering and further information please visit:
www.routledge.com

Related titles from Routledge

Pina Bausch
Routledge Performance Practitioners series
Royd Climenhaga

All books in the **Routledge Performance Practitioners** series
are carefully designed to enable the reader to understand the work
of a key practitioner. They provide the first step towards critical
understanding and a springboard for further study for students on
twentieth-century performance, contemporary theatre and theatre
history courses.

This book is the first English-language overview of Pina Bausch's
work and methods, combining:

- an historical and artistic context for Bausch's work
- her own words on her work, including a newly published
 interview
- a detailed account of her groundbreaking work *Kontakthof*, as
 performed by Tanztheater Wuppertal and by ladies and
 gentlemen over 65
- practical exercises derived from Bausch's working method for
 artists and students of both dance and theatre.

Each section draws on the entirety of Bausch's career and returns
to the works themselves as means of asking essential questions of
performance. Bausch's process is here revealed as a model of
collaborative development leading to a performance practice of
varied means and individual engagement.

ISBN13: 978–0–415–37521–4 (hbk)
ISBN13: 978–0–415–37522–1 (pbk)
ISBN13: 978–0–203–09895–0 (ebk)

Available at all good bookshops
For ordering and further information please visit:
www.routledge.com